IMAGES
of America

CAPE FEAR
BEACHES

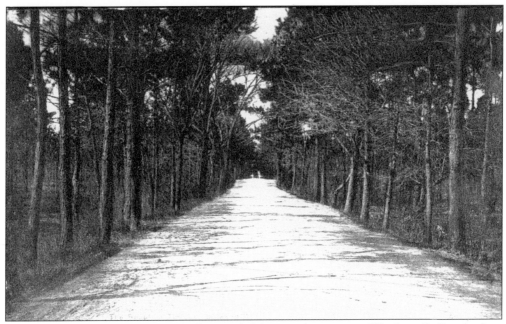

A road covered in sun-bleached shells once led from Wilmington to Wrightsville Beach; then it was paved and renamed "Wrightsville Avenue." In 1884, the Shell Road was "bristling with an almost unbroken line of carriages, buggies, wagonettes and other vehicles," according to the local newspaper. Despite the traffic, potholes weren't much of a problem. "When a hole got in it, they dumped a load of oyster shells on it," said John Hall in 1978. (Lower Cape Fear Historical Society.)

This book is dedicated to Peggy Moore and William E. Perdew, faithful friends of Cape Fear Museum.

IMAGES
of America

CAPE FEAR
BEACHES

Susan Taylor Block

ARCADIA

Published by Arcadia Publishing,
an imprint of Tempus Publishing, Inc.
2 Cumberland Street
Charleston, SC 29401

Printed in Great Britain.

Library of Congress Catalog Card Number: 00-103466

For all general information contact Arcadia Publishing at:
Telephone 843-853-2070
Fax 843-853-0044
E-Mail sales@arcadiapublishing.com

For customer service and orders:
Toll-Free 1-888-313-2665

Visit us on the internet at http://www.arcadiaimages.com

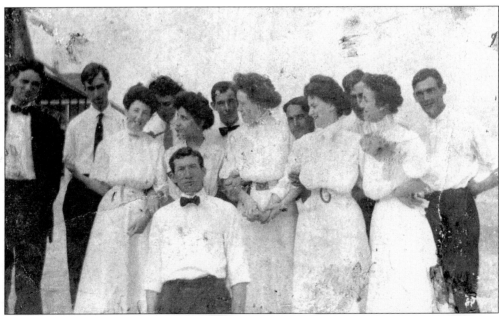

Members of this 1910 Wrightsville Beach houseparty are (left to right) George Peschau, Tom
Speiden, Julia Parsley, unknown, unknown, Ida Brown Speiden, Dick Dunn, Lauriston Hardin,
Stevenson Brown (peeping through), Grayson Peschau, Billy Krafft, Jennie Hardin, and Ted
Brown. (Brown-King.)

CONTENTS

Acknowledgments 6

Introduction 7

1. Roughing It 9

2. Hot Stuff 33

3. Golden Beach 61

4. Another Experience 91

5. The Neighbors 103

Select Bibliography 125

Photograph Donors 126

Index 126

ACKNOWLEDGMENTS

Cape Fear Museum director Janet K. Seapker conceptualized the creation of all three photo anthologies (*Along the Cape Fear*, *Cape Fear Lost*, and *Cape Fear Beaches*) and has been a constant source of information. In addition, many individuals provided assistance with this book, contributing either professional services, facts, or memories: Timothy Bottoms, Beverly Tetterton, Merle Chamberlain, Bill Reaves, Barbara Rowe, Grace Russ, Wendy Marshall, Lucy Ann Glover, Harry Warren, Suesan Sullivan, Henry Chisholm, Jenean Todd, John Timmerman, Diane Cobb Cashman, James Rush Beeler, Joe Sheppard, Chris E. Fonvielle, Elizabeth Brown King, Eleanor Wright Beane, Eva Cross, Annie Caroline Reid, Bill Creasy, Elaine Creasy, George Clark, Margaret M. Perdew, Florence M. Dunn, Nancy W. Henderson, Hugh MacRae II, Delmas Haskett, Clarence Jones, Luther Rogers Jr., Anna Pennington, Ian Lamberton, W. Andrew Boney, Sue Boney Ives, Lillian B. Boney, Leslie N. Boney, Columbus Efird, Marie Solomon Kahn, Betty Yopp Dowdy, Donnie M. Council, Catherine Solomon, Naomi Yopp, Dave Carnell, Joe Bennett, Jerry Parnell, Joe Whitted, Jean Hall Wessell, Taylor E. Cromartie, J. Laurence Sprunt Jr., Alison H. Block, William B. Block, Carolyn Hall, George Evans, Jay Johnson, Geneva Age, Ruth Ann Fredericks, Juanita Lacewell, Georgie Hurst Franks, Silvey and Cecil Robinson, Hannah Nixon, Margaret Graham, Dick Dunlea, Katherine Ennett, Mary Robinson Haneman, Kenneth Sprunt, Susie Hamilton, Ed Turberg, Julia Jones, Janice Kingoff, Blair Sloan, Isabel James Lehto, Anne Russell, Rosalie Carr, Marguerite MacRae Boucher, Linda Honour, Tabitha H. McEachern, Geraldine Taylor, Margaret Herbst, Carolyn Hall, Jean Hall Wessell, Ed Thorpe, Catherine M. Gerdes, Betty H. Taylor, Joseph W. Taylor, Roi Penton, Barbara Hoppe, Elizabeth Penton Mullen, Claud Efird, Lori Efird, Verge Beall Emory, and Betty Sparks Eagles.

Special thanks are due to photographer Melva Pearsall Calder, for her expertise in reproducing old pictures; Suzanne Nash Ruffin, for artistic editorial skills; Ann Hewlett Hutteman, for reviewing the manuscript; and to my very patient husband and best friend, Frederick L. Block.

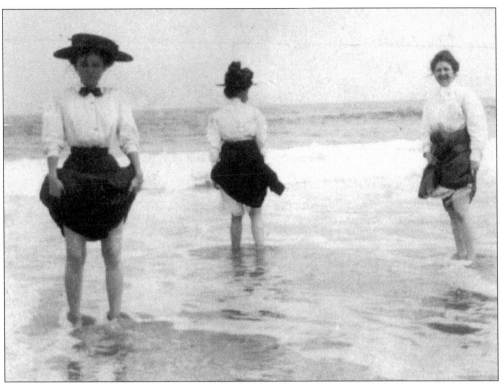

The lure of the ocean proved stronger than convention when these members of the Toomer family visited Wrightsville Beach, about 1909. (Lower Cape Fear Historical Society.)

INTRODUCTION

A night, a girl, a moon, a band, a ragtime tune, strolling on the old boardwalk, just a bit of summer talk, love thrills you through and through.
—Anonymous handwritten message on a 1905 Wrightsville Beach postcard.

To many people, Wrightsville Beach is the intersection of Wilmington, North Carolina, and the Atlantic Ocean. Fondness for the particular barrier island is unique to each individual. Today, all people may walk the strand, jump the waves, and watch the sun turn orange over Banks Channel at day's end. But it is our personal memories that make a place on the map a place in our hearts: a special barefoot stroll down the beach on a moonlit night; the first morning you remember waking up to the lilt of gentle waves and the kiss of the ocean breeze; or maybe a favorite bathing suit you wore as a teenager, when Wrightsville Beach was high school east.

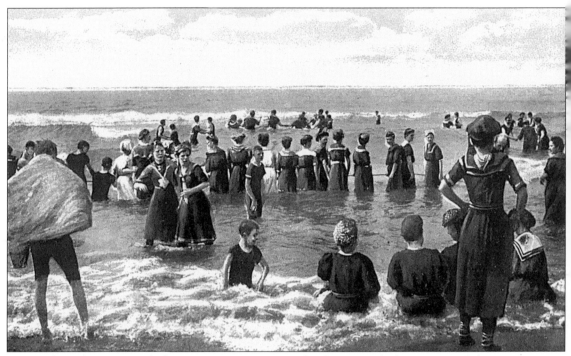

"The great source of pleasure is variety," Samuel Johnson said about 1748. If that's true, Wrightsville Beach is positively orgiastic. Wind, water, shoreline, and sky change from hour to hour, sometimes bringing aesthetic ecstasy, sometimes horror. Here bathers enjoy the surf as clouds threaten their party. (1992.31.492.)

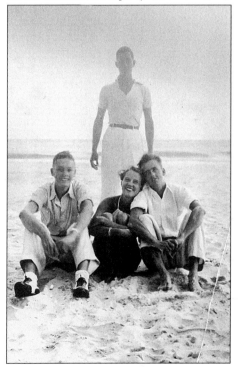

Here, Harry Stovall, Elizabeth Whitehead, and Mike Brown (from left to right) pose on the south end of Wrightsville Beach, about 1933. The man standing behind the group is John Schiller. (Brown-King.)

One
ROUGHING IT

The earliest inhabitants of Wrightsville Beach slept in hammocks or tents, and a whole family could eat for $25 a month. Fishing shacks dotted the scant dry land on what we know as Harbor Island and Civil War wrecks still appeared at low tide. As rail transportation improved accessibility, shacks gave way to quaint cottages and a portion of Wilmington began to take refuge at Wrightsville every summer, both to escape the city's heat and to avoid missing out on all the fun.

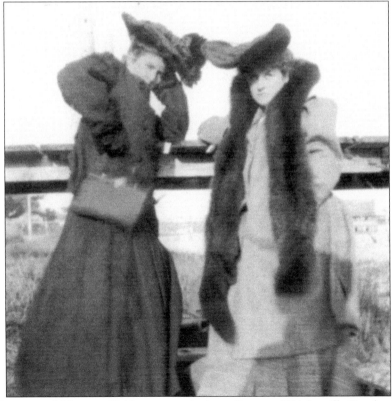

Evoline Burruss and Margaret Bridgers sported winter finery at Wrightsville Beach, about 1900. (Lower Cape Fear Historical Society.)

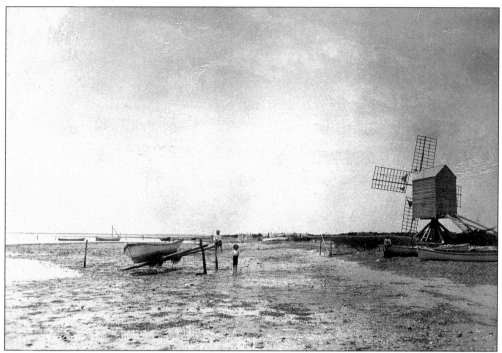

Windmills like this one were the precursors of electric power at Wrightsville Beach in the 1890s. Power from the mill pulled water from an artesian well at The Hammocks. Three-inch galvanized pipe then carried it along the trestle and down the beach as far as Colonel F.W. Foster's cottage, the oldest house on the beach, at 513 South Lumina Avenue. (N.C. Archives and History.)

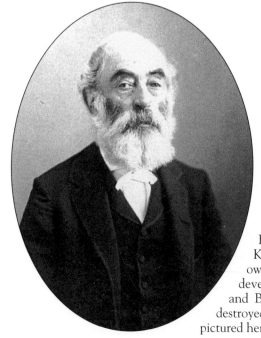

The Schloss and Nathan families once owned land that stretched from near the Blockade Runner to the southern inlet. Known originally as Ocean View, it had its own windmill to supply power for the new development, including the Ocean View Hotel and Bath House. The windmill and hotel were destroyed in the hurricane of 1899. Marx Schloss is pictured here, about 1890. (Reid Nathan.)

Jeanette Schloss Nathan and her nurse were photographed, in 1930, on the boardwalk, near the Nathan Cottage at 712 South Lumina Avenue. The Schloss, Nathan, and Bear families, all relatives, donated land for several buildings, including Lumina. (Reid Nathan.)

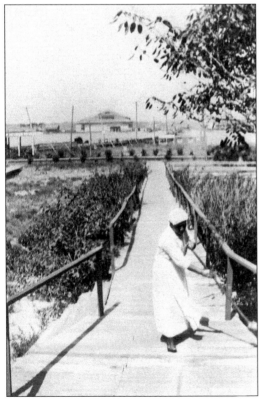

Here, a maid sweeps the Bears' walkway that led from their house to the sound, about 1917. Harbor Island and the trestle are visible in the background. (IA4786.)

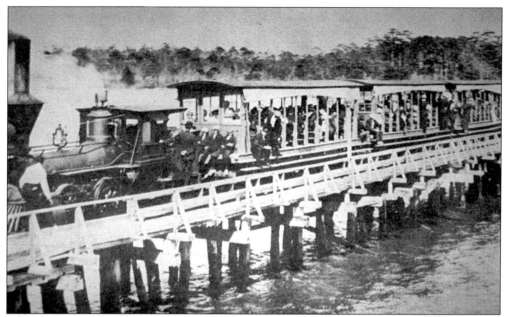

The Wilmington Seacoast Railroad completed the first railway from the depot at Ninth and Orange Streets in Wilmington to The Hammocks on June 16, 1888. Railroad president William Latimer drove a ceremonial sterling silver spike to complete the line. The spike survived and is displayed at the Lower Cape Fear Historical Society. (IA168.)

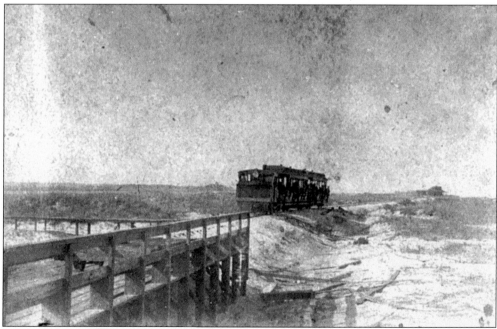

When the Ocean View Railroad began operations in 1889, there was little to view on the south end of Wrightsville but the ocean. Owned primarily by the Nathan and Schloss families, the Ocean View development eventually included a small pavilion and several hotels. By 1905, Tide Water Power and Light had taken over the beach railways and eclipsed Ocean View with its own dazzling pavilion: Lumina. (IA340.)

12

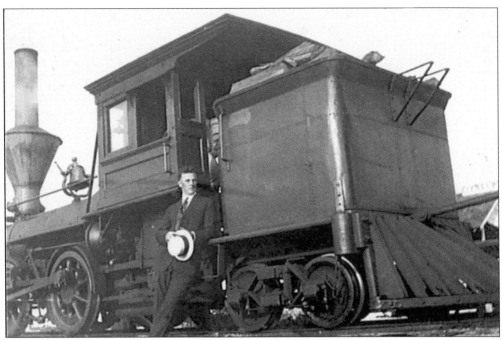

A man identified only as "Wade" stands against the beach car engine. The locomotive, pictured here about 1906, replaced an earlier one that had exploded. William Latimer, president of the Wilmington Seacoast Railroad, named the engine "the Bessie," after his niece. (1987.23.34.)

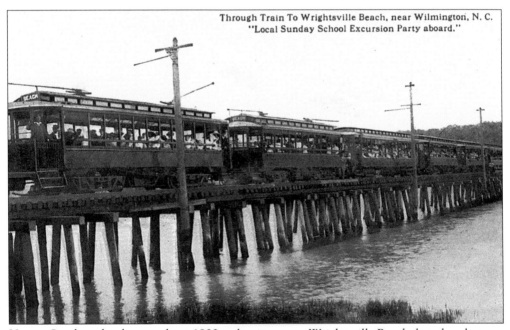

Through Train To Wrightsville Beach, near Wilmington, N. C.
"Local Sunday School Excursion Party aboard."

Here, a Sunday school group about 1900 makes its way to Wrightsville Beach, but church group excursions were common for years in June. Longtime beach resident Beulah Meier said, "All the kids that lived on the beach were hoping we knew somebody in every Sunday School. They brought plenty of food; fried chicken, ham, you name it." (1986.25.6.)

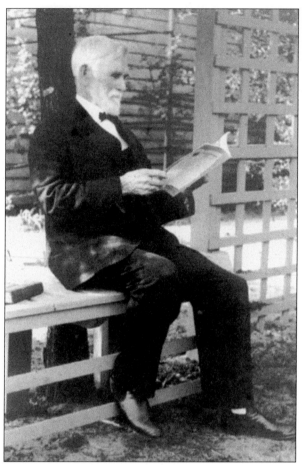

Benjamin Franklin Hall (1842–1934) was a Civil War veteran who fought at Gettysburg and was present when Robert E. Lee surrendered at Appomattox. He established a wholesale grocery business on Wilmington's waterfront and built one of the first houses at Wrightsville Beach, at 305 South Lumina. It stood one building south of what is now the Blockade Runner Hotel property and what was then, the construction site for the Seashore Hotel. The vacant lot in between, 301 South Lumina, is now the site of the Sprunt-Murchison-Gornto House. The Halls' southern neighbors were the Northrops, who lived at 309 South Lumina Avenue.

B.F. Hall, a scholarly Presbyterian, was married to Margaret Tannahill Sprunt, sister of historian James Sprunt. On August 14, 1897, various members of their large family were enjoying a late afternoon swim in front of their cottage. Mr. Hall's seven children were bright and athletic. All three daughters graduated from Wellesley. But the ocean respects no person; to Mr. Hall's horror, several of the children and a cousin, John Sprunt, were caught suddenly in an undertow. The next day, it was front-page news.

Thanks to a lifesaving crew that included James Hall, John Hall, Dawson Latham, James Walton, George Davis, Edwin Northrop, and Edwin Metts, no one drowned .

Benjamin Franklin Hall, pictured here during a calm moment in 1914, once said, "If I had to live my life over again, I would choose the 19th century. It was a more orderly existence than today." (Lower Cape Fear Historical Society.)

14

The Clarendon Yacht Club, located at about 601 South Lumina Avenue, was incorporated July 15, 1895. Members included James F. Post Jr., Dr. W.J.H. Bellamy, William Rand Kenan, and W.A. French. The clubhouse was destroyed in the 1899 hurricane. (Bill Creasy.)

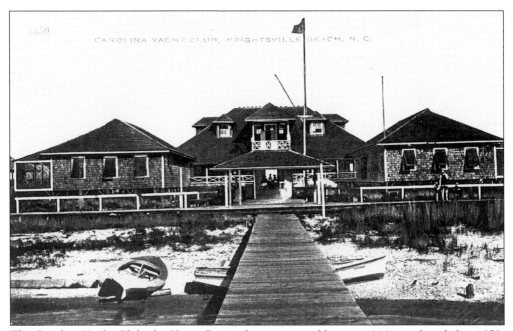

The Carolina Yacht Club, the Henry Bonitz design pictured here in 1910, was founded in 1853. It also was damaged in the Great Storm of 1899, but endured and thrives today, many hurricanes later. Early membership rosters read like an extensive family chart of Wilmington's famous "cousinhood." (IA1519.)

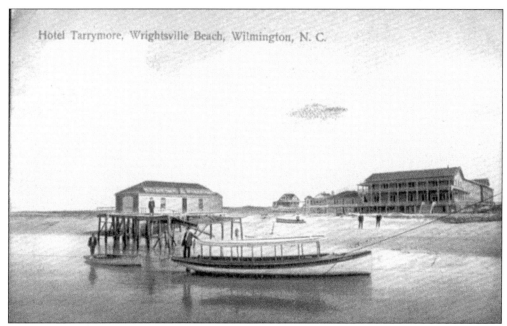

Hotel Tarrymore, Wrightsville Beach, Wilmington, N. C.

The Tarrymoore Hotel, built in 1905 by W.J. Moore of Charlotte, was located at Station One. Hotel guests often went fishing on the launch *Atlanta* (seen on left), somewhat overshadowed here by a handsome yacht. (Lower Cape Fear Historical Society.)

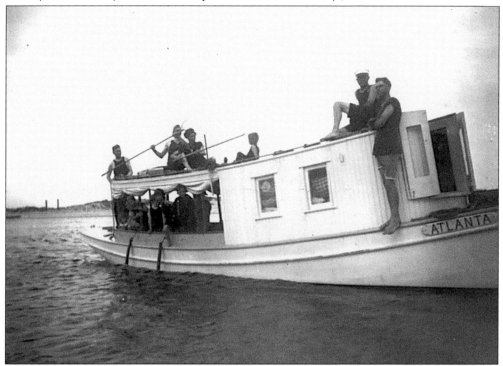

By 1914, Hugh MacRae had transformed the Tarrymoore into the Oceanic Hotel, and another boat had replaced the little launch. This photo of the new *Atlanta* was taken by Wilmington photographer William A. Williams. (1980.45.28.)

16

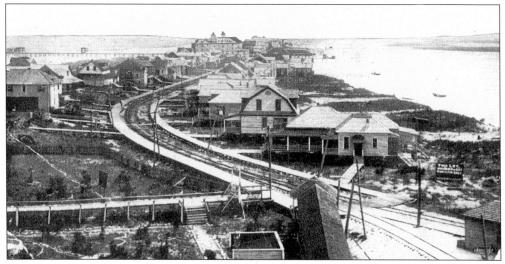

In 1912, this was the view, looking south, from the Oceanic Hotel tower. Streets composed of rails and boardwalks gave the beach a rustic look. By contrast, the Oceanic's elegance made it a fitting summer home to several members of the Kenan family, who spent winters at Palm Beach. (Lower Cape Fear Historical Society.)

Thomas H. Wright was being quite literal when he coined the name, "Little Chapel on the Boardwalk," a joint venture of First Presbyterian and St. James Churches. Members of both churches could soak up Calvinist doctrine in July and participate in Episcopal services in August. The building was located on South Lumina Avenue, opposite the present site of St. Therese Catholic Church. Little Chapel on the Boardwalk is now located on North Lumina Avenue at Fayetteville Street and is solely Presbyterian. This photo was taken about 1907. (Bill Creasy.)

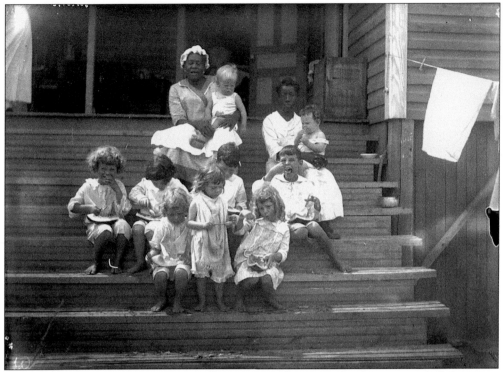

Early Wilmington photographer William A. Williams took this picture of his nine grandchildren and their two black "nurses" in 1916. Most cottages had separate living quarters for servants, but a few homeowners provided bedrooms within the house for employees. (1980.45.97.)

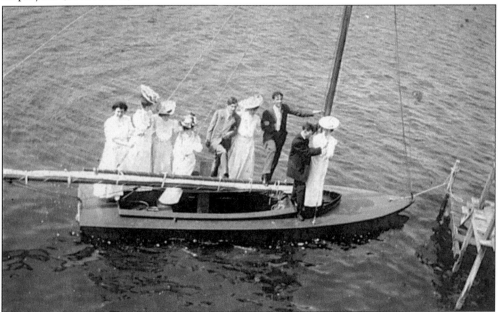

A group of well-dressed sailors, most members of the Williams and MacMillan families, tempts gravity on a skiff near Wrightsville Beach, about 1910. (1984.83.9.)

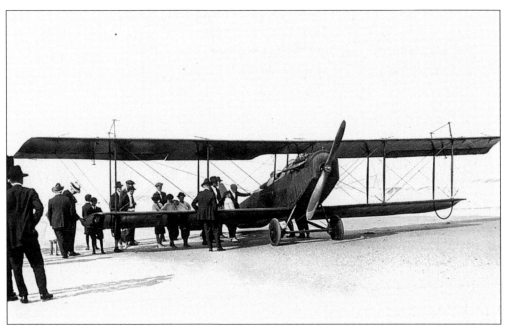

In 1910, H.M. Chase and M.F.H. Gouverneur built a 1,200-pound airplane on Shell Island, known then as Moores Beach. It took off November 15, and flew south briefly at an altitude of 5 feet. "Longer flights will not be attempted until the driver [Mr. Chase] has fully acquainted himself with the machine," it was announced. However bumpy, it was the first flight made in the state by North Carolinians. (1988.39.167.)

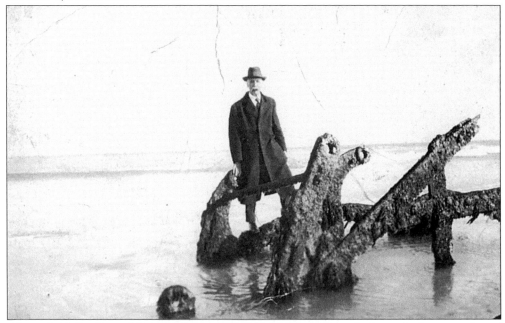

About 1915, Dr. Dougald MacMillan stands on one of several wrecked vessels that once dotted Wrightsville Beach. Two of the vessels were beached blockade runners, the *Fannie and Jennie* and the *Emily*. Born at Sloop Point Plantation in 1844, MacMillan fought in nine Civil War battles. "I was shot four times and I feel it now," he said in 1930. (1987.23.30.)

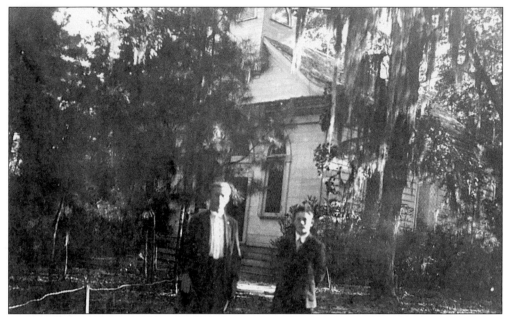

Dr. Thomas H. Wright, the son of Judge Joshua Grainger Wright, built Mount Lebanon Chapel, off Airlie Road, in 1835. Judge Wright's land holdings on the sound were so extensive that it became known as Wrightsville Sound. Later, the name became attached to the neighboring beach. Appropriately, Dr. Wright's chapel was an important part of Wrightsville Beach life in the late 1800s. Summer residents boated to the landing and made their way to the tiny house of worship, where none but the most centered could separate sacred thought from sailing craft.

Dr. Wright's granddaughter, Caroline Green Meares, remembered those days: "Memories cluster thick and strong around this little Chapel where the old residents would meet for worship, in flowered organdies and embroidered waistcoats, and after the little organ would peal its cracked 'Amen,' would gather for the social hour.

"Neighborly chats were held over the backs of pews; parties planned and the coming boat race discussed beneath the shadows of those towering oaks, for Wrightsville held the honor of having one of the oldest boat-racing clubs in the U.S. [second to the New York Yacht Club] and even this fact did not tempt them from the paths of duty: NEVER SAILING ON THE SABBATH."

The chapel is pictured here, behind two unidentified men, on a quiet day in 1922, when Sadie and Henry Walters were in residence at Airlie. By 1924, nearby St. Andrews-on-the-Sound was accommodating worshippers from the beach, and Mount Lebanon became a family chapel until Sadie Jones Walters's death.

St. James Church, which owns Mount Lebanon Chapel, holds summertime services early Sunday mornings. The lack of air conditioning causes few complaints as the sound of Airlie's songbirds wafts through the open windows. (1988.39.110.)

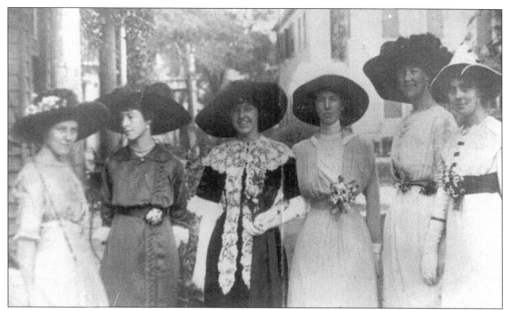

When Sadie and Pembroke Jones's daughter, Sadie, married architect John Russell Pope, in 1912, Lebanon Chapel provided only enough room for family and beloved servants. However, 500 coveted invitations went out to the reception, held at Airlie. Here, guests (left to right) Helen Williams, Bessie Craig, Nora Corbett, Madeleine Corbett, Margaret Corbett, and Isabel Williams pose, ready for the big party. (Jane Iredell Wright.)

Pembroke Jones (second from left) and members of the Robert Williams family pose at Pembroke Park, about 1905. Pembroke Jones was an avid yachtsman at Wrightsville Beach, in New York, and at Newport, where he lined a billiard room with cases for his trophies. (Lower Cape Fear Historical Society.)

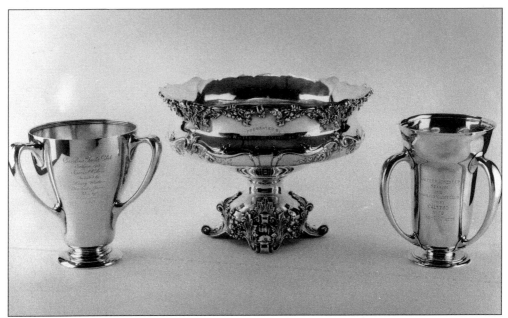

Pembroke Jones and Henry Walters sponsored and presented sailing trophies to winners of the Carolina Yacht Club regattas. Despite Pembroke's trophies, the Joneses did not keep up with Henry Walters's yacht; he owned the *Narada*, a 224-foot-long brigantine. Jones and Walters awarded these three trophies to Edwin Anderson Metts, in 1912 and 1913. (Brown-King.)

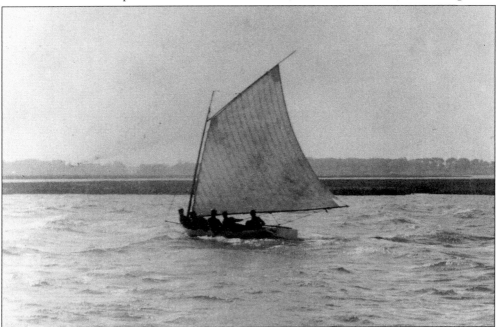

Earlier, in 1899, Edwin A. Metts won one of his first Carolina Yacht Club trophies, racing the *Mabel* (seen here) in a Fourth of July regatta. That same year, Captain J.D. Latham won the Carolina Canoe Club race in the *Dolphin*, and J. Hardy LeGwin, Joseph J. McLoughlin (one-half mile in 55 seconds), and James K. Forshee topped out the Seashore Hotel bicycle competition. (Brown-King.)

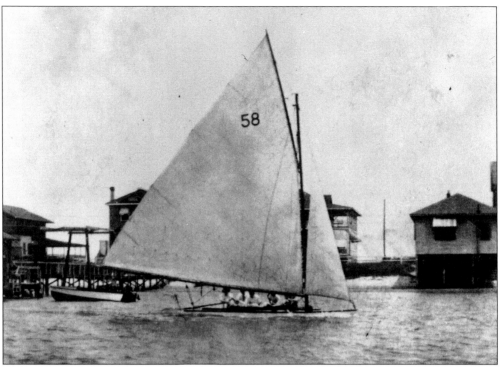

Number 58, the *Puzzle*, was Edwin Metts's favored yacht from 1909 until 1921. Pembroke Jones himself enjoyed his own yacht, the *Idler*. The local paper commented, "She is of the property of Commodore Jones and is really named after him, in recognition of the fact that he never allows himself to become fatigued." (Brown-King.)

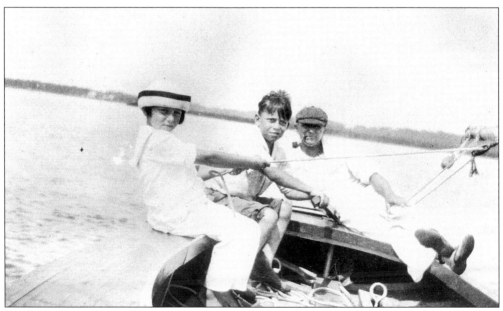

Elizabeth Green Metts, James Isaac Metts, and Edwin A. Metts take a break, about 1920, on Banks Channel. (Brown-King.)

This 1904 construction photo was contributed by Lillian Sebrell Paso, whose father, S.W. Sebrell, was the contractor for the original structure. The slanted walkway went all the way to Banks Channel. (IA949.)

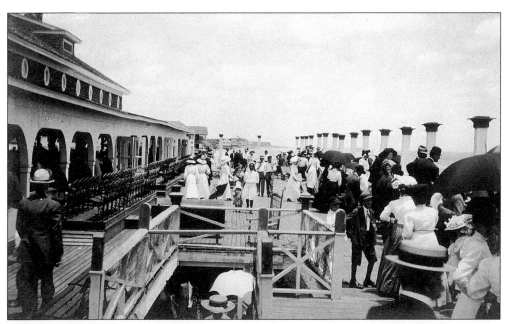

When complete, Lumina became the summertime destination point of the South. Here visitors enjoy the promenade, about 1908. Not sun seekers, turn-of-the-century Southerners sported hats, carried parasols, and wore voluminous clothing. (1988.60.1.)

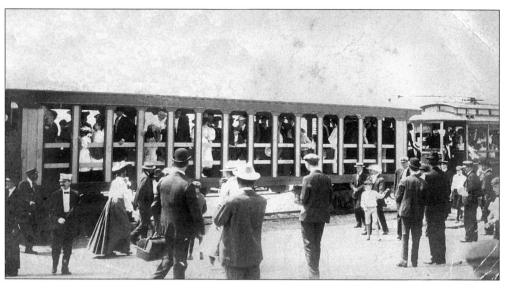

Lumina, at Station Seven, was the last stop on the beach car line. The depot is pictured here, about 1906. As many as a hundred passengers crowded into each car on summer weekends to enjoy what Charles W. Riesz Jr. termed the "Cathedral of Recreation." However, Lumina had its limits. In 1919, management announced that "shimmy-shiver" dancing was not permitted. "The orchestra will stop playing and the drums will give a warning signal. After this, it is a case of quits or leave the floor." (1987.23.11.)

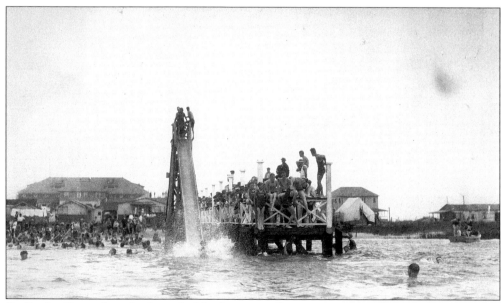

On Banks Channel, at the far end of the Lumina walkway, visitors found swings, diving boards, and a precipitous sliding board to augment oceanfront diversions. The group of cottages seen in the background was known as Pomander Walk. (New Hanover County Public Library.)

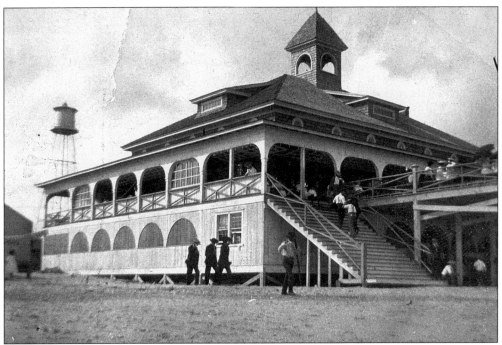

Lumina looked like this for only four years, from 1905 to 1909. Expansions called for the removal of the cupola and the addition of a 7,100-square-foot terrace known as the Hurricane Deck. The new building was topped off with 6-foot-high lighted letters that spelled Lumina, to match the height of the illuminated sign atop the Oceanic Hotel. (Barbara Marcroft.)

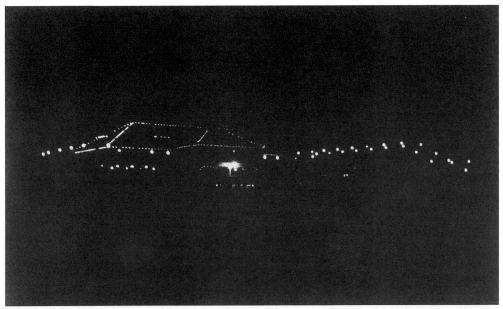

In 1911, Tide Water Power and Light added thousands of incandescent bulbs to the roof and the Banks Channel walkway, making it a colossal billboard for its product. The roof lights were maintained until 1939, when the building was sold. Lumina's most famous bulb changer was a lanky young man named David Brinkley. (1988.39.68.)

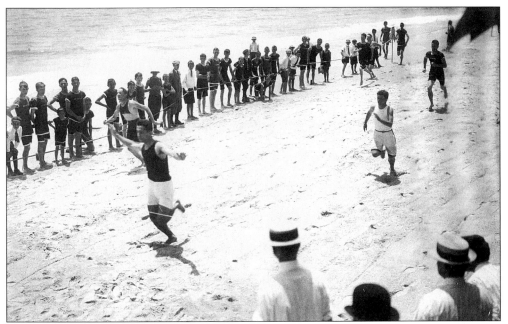

Harry Solomon left the competition behind to win the 220-yard dash on July 4, 1911, at Lumina. Most of the spectators wore black bathing suits that they rented for a dime from the bathhouse. For a quarter, visitors could rent a wooden locker and take a cold shower. (1992.31.368.)

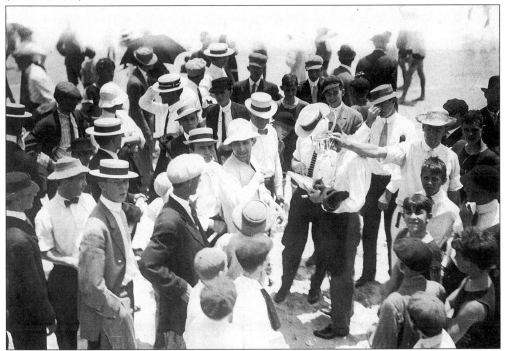

Later that day, Mr. Solomon (wearing the floppy white hat) received a silver cup for his efforts. Trophies presented at Lumina for everything from baby contests to bathing beauty competitions are valued keepsakes in a number of Wilmington households. (1992.31.367.)

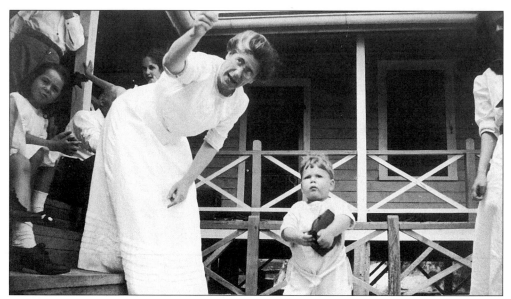

In this 1911 photo, Ida Lyon Solomon instructs her grandson, Adolph Solomon, while his young cousins look and listen. At that time, Wrightsville's summer residents adopted a sort of rigid informality that included scheduled family swims and proper dress for meals. Afternoon naptime was enforced, even though lots of energetic children merely played possum. (1992.31.385.)

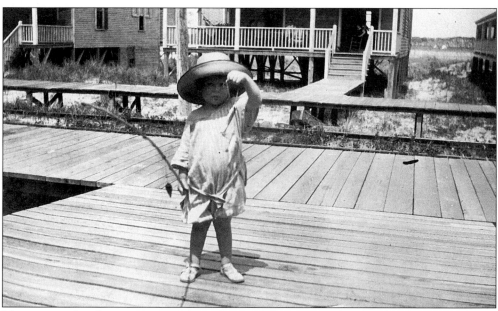

It's a scene played out in every fishing family's life. A young boy catches his first fish and someone takes a picture of it. Here, little Adolph Solomon stands, frozen in time, showing off his catch. (1992.31.386.)

Tide Water Power Company kept the name Lumina prominent and, as owners of the streetcar line, profited compoundly by its rampant success. Wilmingtonians boarded the orangy-yellow beach cars at the corner of Front and Princess Streets, pictured here about 1908. Owner Hugh MacRae, who orchestrated both business and beauty for Lumina and the Oceanic, insisted roses be planted along the trestle. Some still exist, on Park Avenue. (Lower Cape Fear Historical Society.)

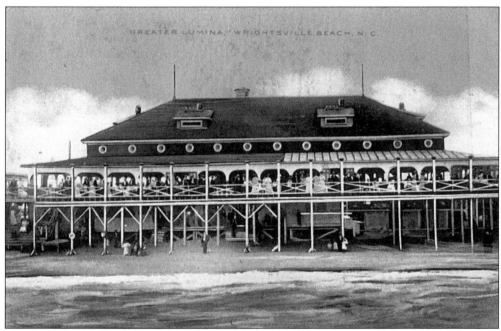

Though only four years old, Lumina was enlarged in 1909 to accommodate the crowds that came from several states around. As many as 3,000 visitors swarmed its decks and dance floor on the Fourth of July. Lumina is pictured here on a very quiet day in 1910. (1992.31.230.)

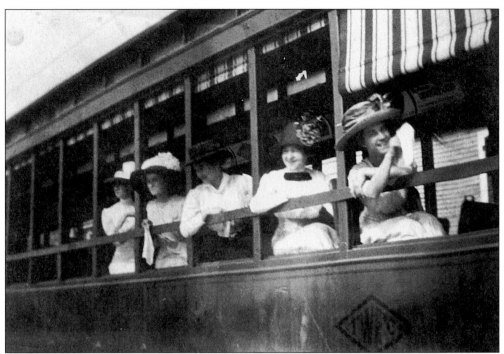

These ladies, photographed about 1910, are all smiles as they head for Lumina, but old-timers reported stressful moments on the beach car, in the days before satellite weather forecasting. Never knowing if heavy rain and wind was the edge of a hurricane or simply the full brunt of a summer storm, women, children, and most men headed back to Wilmington. When waves lapped over the trestle, the trip became a prayer meeting. (1986.25.6.)

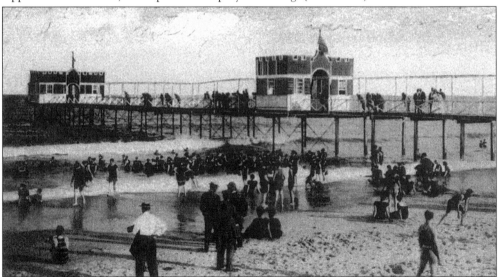

The Seashore Hotel at Station Three opened in 1897, but the 700-foot steel pier wasn't added until 1910. The pier featured a pavilion, an observatory deck, and enough lights to create a dazzling show when the sky turned black. Damaged by a 1920 storm, the remnants broke away completely during a 1921 northeaster and slammed into a house owned by Janie Dunn, completely destroying it. (Lower Cape Fear Historical Society.)

B.F. Hall's "backyard," next door to the Seashore Hotel, was the ultimate playground for his grandchildren. Here, William and Margaret T. Hall enjoy good times, about 1917. William died in 1934, at age 19, in an automobile accident. Peggy Hall (1910–1992) was director of St. John's Art Gallery from 1964 to 1972. (1981.53.1.)

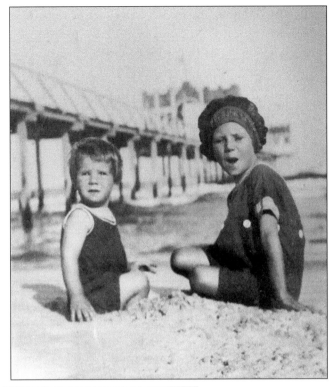

The Northrop Cottage, seen here in 1921, survived the fire, but it was demolished about 1950. Built by Samuel Northrop before 1900, it evolved into a guesthouse, operated by Mrs. W.H. Northrop. "Bathing direct from cottage, choice seafoods a specialty," she advertised. The Woodbury Cottage now stands on the site. (Silvey and Cecil Robinson.)

31

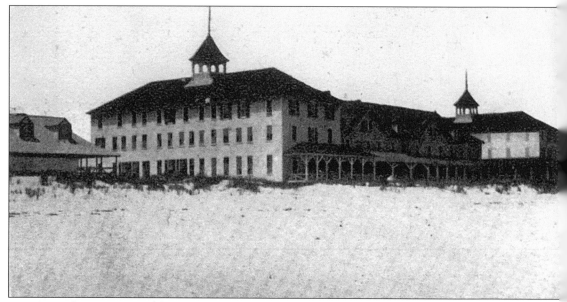

Part of Benjamin Franklin Hall's beach cottage, built in 1894, is visible on the left, next door to the Seashore Hotel. On June 26, 1919, the hotel and the house burned to the ground in a blaze so fierce that the reflection turned the ocean into a red sea. Mr. Hall wrote, "The fire was found in the Seashore Hotel a few minutes after ten o'clock. I had just gone to bed after taking a bath. I heard a sharp noise in the direction of the hotel, but attached no special importance to it until Jane [Hall] came in to my room, and told me the hotel was on fire, and I had better get up and dress. I did so leisurely, seeing the fire had not made great headway, but by the time I had dressed the flames were bursting through the building rapidly, and I gathered up in two baskets most of the things in my room.

"None of us of course left while the buildings were burning very brightly. I had a strong hope at one time that our cottage would be saved. In fact, it did not catch on fire until the hotel walls had fallen in, but in the meantime it had become very hot and the men throwing water had no regular organization, and the blaze first took the building at the sharp angle over the dining room, which they could not reach with water without climbing the steep side of the roof. After it once caught there, it was hopeless and soon swept through the building."

Meanwhile, a bucket brigade, usually composed of men, continued to douse the Northrop Cottage next door to the Hall house in hopes that they could prevent a domino effect fire from burning the south end of the beach. Neighbor Louise Wise Lewis led a group of women who waded into the channel, dipped buckets, and saved the night. (Lower Cape Fear Historical Society.)

Two
HOT STUFF

After the 1909 expansion, thousands of lights on Lumina's roof served as a beacon, literally, to the occasional airplane and, symbolically, to hordes of earthbound railway tourists. Pageants, parades, and promotions came as fast as thunderstorms on August afternoons and real estate prices "soared" from hundreds to thousands as investors realized there was gold in "them there" views. Windswept landscapes began to disappear and a few hearty beachcombers contemplated staying on the island after Labor Day.

Jimmie Sprunt was the picture of youthful beach fashion, about 1918. Early on, his grandfather, cotton merchant and historian James Sprunt, carved out a family niche at Wrightsville Beach, in the 500 block of South Lumina, known casually as Spruntsville. (IA5145.)

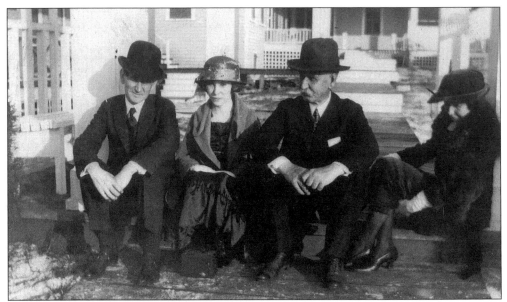

Mr. and Mrs. Boardman McKenzie of Charleston sit with John D. Bellamy Jr. and his daughter-in-law, Ann T.S. Bellamy, outside Mr. Bellamy's house, about 1916. Built by Solomon Fishblate, the cottage still stands at 315 South Lumina Avenue and is the summer home of Lillian Bellamy and Leslie N. Boney. (New Hanover County Public Library.)

Sarah Cantwell and her daughter, Maggie, enjoy a day at the beach about 1917. Yards of fabric didn't seem to be a problem. In fact, it was the law. "In the interest of human decency and morality, be it ordained and it is hereby ordained that women shall not be allowed to appear publicly within the corporate limits of the town of Wrightsville Beach in bathing suits without stockings and skirts of reasonable length. All immodest exposure of the person will be considered a violation of this ordinance, carrying a penalty of $10 for the first offense and $50 for each subsequent offense"—Wrightsville Beach Mayor Thomas H. Wright, 1916. (1981.10.170.)

On July 20, 1919, the *Wilmington Star* reported, "A one-step dancing contest for juveniles only at Lumina Pavilion, proved one of the rarest treats of the season Friday night with little Miss Anna Gray Johnson of Tarboro dancing with John Boatwright Gwathney of Short Hills, N.J. capturing first prize. Consolation prizes were awarded to Beverly Northrop dancing with Peter Browne Ruffin of Tarboro, and Elizabeth Metts dancing with Jimmy Metts, her brother." Young Elizabeth and Jimmy Metts are shown here practicing their routine. (Brown-King.)

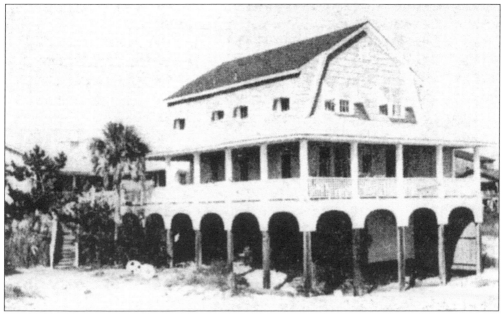

This was the second Thomas H. Wright cottage, at 99 South Lumina Avenue. The first one burned in 1934 but was replaced with a copy. Architect James Borden Lynch is credited with the design. Eleanor Wright Beane, Mr. Wright's daughter and Pembroke Jones's godchild, remembers the Oceanic Hotel as the "centerpiece" of her summer neighborhood. (Bill Creasy.)

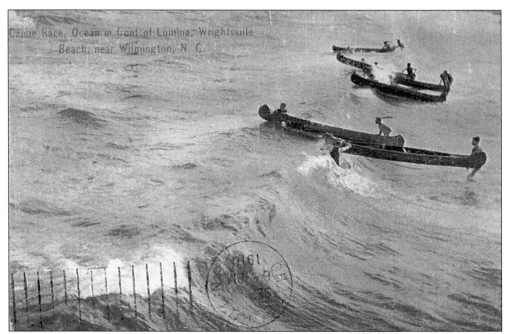

Canoe races were popular at Wrightsville Beach in the early 1900s. According to Kenneth M. Sprunt, "The crews would line up on the beach, near the tide line and, at the sound of the gun they would launch the canoes in the water, paddle out furiously a half a mile to a buoy, circle the buoy and ride the wave back in and carry the boat up to the starting line." (1992.31.493.)

Reston Stevenson, pictured here at Wrightsville Beach about 1920, was one of the area's legendary canoe racers. In June 1902, he and a fellow student at the University of North Carolina, H.B. Short Jr., paddled their canoes from Chapel Hill to Wilmington, where they were cheered at Point Peter by passengers on the steamer *Wilmington*. (1998.31.8.)

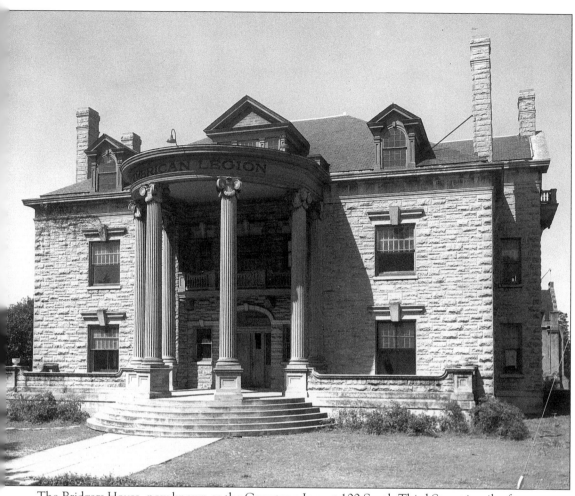

The Bridgers House, now known as the Graystone Inn, at 100 South Third Street is miles from Wrightsville, but there's a lot of beach history in its walls. This was the home of Burke Bridgers, a particularly energetic beach canoeist who had a summer cottage at 425 South Lumina Avenue. According to Kenneth M. Sprunt, a family friend, Bridgers and a friend pitted their canoeing skills against the Staten Island ferry about 1910. By paddling furiously and making good use of the boat's wake when it slowed to berth, they were triumphant.

In 1912, Mr. Bridgers also introduced the first rod and reel to Wrightsville Beach. It was a heavy hickory rod with a Meiselback reel. Hooked on the new contraption, he learned to make fine hickory rods in the attic of the Bridgers House. However, the tedium of sanding them got to him after a while, and he and Wilmingtonian Bob Calder devised a sanding machine using one pedal on an old bicycle they found in the attic and a small motor. Designed to rotate the rod an eighth of a turn at every interval, the contraption could sand a whole fishing rod while Bridgers was at work.

Watching the other pedal going round and round with no purpose, Bridgers had another idea. He put a bit of charcoal into a keg of corn whiskey, corked it, and laid it in an old baby cradle. Attached to the extra pedal with a pulley, the whiskey rocked and aged nicely—far from the eyes of local prohibition officers.

This photograph was taken by Peter L. Knight Jr. about 1950, after the house was sold to the American Legion. (Lower Cape Fear Historical Society.)

The Banks Channel depot was pretty rustic about 1898. This photo was taken by Eric Norden, a Swedish immigrant who lived on Wrightsville Sound. (1980.36.177.)

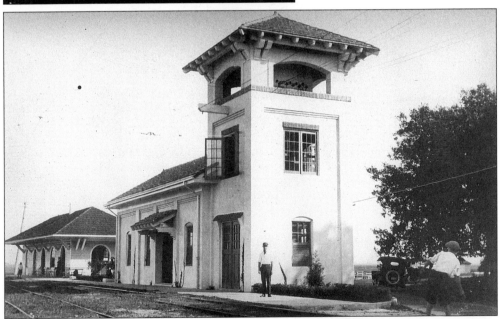

The elegant beach car depot at Banks Channel, designed by Henry Bonitz, was constructed in 1917. Other Spanish Mission–style buildings of that period include St. Andrews-on-the-Sound Episcopal Church (1924), the "Villa Margarita" on Harbor Island (1928), and other trolley stops on the Tide Water Power and Light line. (1988.39.61.)

Oliver T. Wallace, pictured here with his wife, Mary Borden, was the chief developer of Harbor Island. When he took over in the 1920s, water still lapped at the back door of the pavilion at high tide. After adding retaining walls and 350,000 cubic yards of soil, it was similar to what the island is today. Wallace also had real estate interests that ranged from Navassa in Brunswick County to the Wallace Building in downtown Wilmington. He developed Brookwood, and donated Wallace Park, on Burnt Mill Creek, to the city.

The Wallaces had two children. The older daughter, Mary Borden, married E. Lawrence Lee Jr., who became president of Shore Acres, the Harbor Island development company. Lee Nature Trail and Lee's Cut are named for him.

The younger daughter, Nancy Wallace Henderson, is a playwright who lives in New York and Chapel Hill. "I remember Wrightsville Beach," she said in 2000, "as a Never-Never Land in my childhood. Families moved down from Wilmington—bag, baggage, and household stuff—every summer, to ramshackle shacks. By season's end, we compared our tans, proudly trod hot boardwalks with toughened bare feet, lay on the strand in the baking sun, and forgot that there was any other way of life." (Lower Cape Fear Historical Society.)

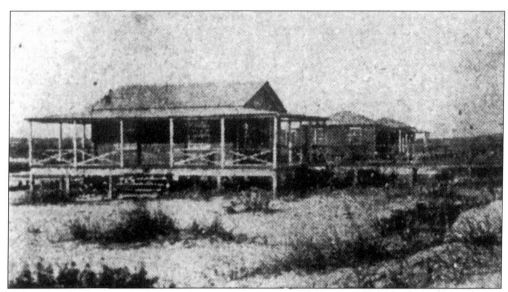

From 1923 until 1926, blacks had their own beach on Shell Island. Developed by two white Wilmingtonians, Thomas H. Wright and Charles B. Parmele, the resort was known as the "National Negro Playground." A pavilion, bathhouse, restaurant, snack bar, and a number of cottages were constructed, but a fire of suspicious nature destroyed everything on the island in 1926. (Bill Creasy.)

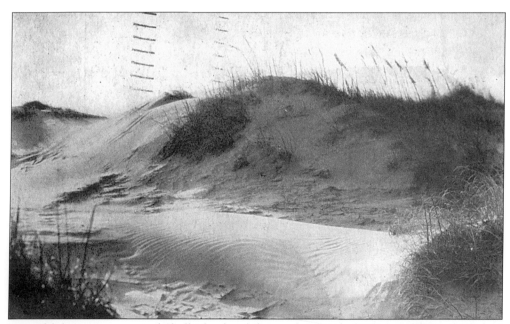

Beautiful dunes once covered Shell Island and the northern end of Wrightsville Beach. Bayard Wootten took this photograph about 1929. (L.H. Reynolds.)

Cecil Hunt remembers when Shell Island was built. "My father and Luther T. Rogers worked at the Victory Shipyard in 1917 and 1918. My father, Carl John Hunt, was a contractor and came from Whiteville to Wilmington. When they got out of the shipyard, Mr. Rogers went into business as a contractor. My father became his general superintendent and during that period of time, they built what was built at Shell Island. I seem to remember somewhere that they had a wooden water tank which they built. Shell Island was an island with a fairly deep inlet at that time.

"People used to fish in the inlet and I used to fish on Shell Island. There were no paved roads to the beach. The paved roads stopped at the mainland. Then you got on what was called the beach car or a flatcar and they drove that across and there was a trestle. In fact, I rode on that thing and the whole railway was almost a trestle. A lot of Harbor Island was low and muddy and had marsh grass on it. They built the railroad tracks through that.

"I was eight or nine years old. When they got to Banks Channel, they would stop and the freight car would have the lumber and materials loaded on it to do the work at Shell Island so they would throw that in Banks Channel when the tide was going towards Moore's Inlet. Sometimes they strapped the materials together and it all floated over to Shell Island. Behind the island there was a pretty deep creek. The men went along in boats and steered it and tried to bring it in on the back of Shell Island in that creek. They would unload it and carry it over to the dunes where they built the pavilion.

"Mr Rogers told me that one time my dad was going over in a boat with some friends that we had and one of them was a black gentleman. His name was James Franks and he was pastor of a black church. Mr. Franks fell overboard and couldn't swim. My dad grabbed him and pulled him back in."

In the 1930s, Cecil Hunt helped Luther Rogers build the Atlantic View Pier, near Lumina. After workmen dynamited through an old ship hull, Hunt swam out with creosoted pilings, two a day. "We took an old Buick motor and rigged it up to some pulleys, blocks and tackle. We built a chute out of wood and we'd get the piling in there. Then an old Buick motor would pull a hammer up on the cable and drop it on the piling, driving it down into the ocean. We bolted girders and braces on the pilings, put the joists and decking on that day before we went home. We put that thing on wood rollers and pulled it up the distance from piling to piling. Then we did two more the next day."

Cecil Hunt is pictured here in 2000, at the home of Luther T. Rogers Jr.

Effie Presson hangs on to her daughter, Silvey, at Lumina, in 1924. Children's festivals and contests were popular pavilion events. Though young Silvey is dressed in her Sunday best, most older children looked forward to the Tacky Party. "Hundreds of children are looking up their old clothes and designing their costumes," stated a local reporter in 1919. (Silvey and Cecil Robinson.)

Silvey Presson met Cecil Robinson in 1938 while swimming in front of Lumina. Young Cecil, a lifeguard at the Oceanic Hotel back when they used a double-ender lifeguard boat, got free passes on beach cars and to Lumina dances. Their Wrightsville courtship took and they were were married in 1941. The couple are pictured here in 2000.

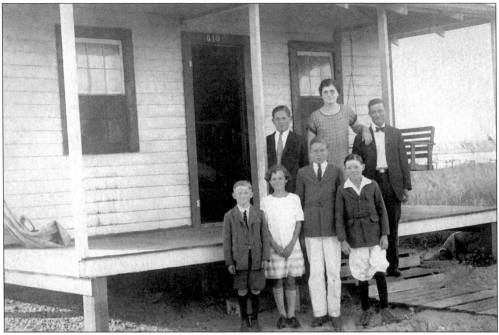

The Robinsons, at 610 South Lumina Avenue, had become year-round residents of Wrightsville Beach in 1924, long before that was popular. Mr. Robinson worked at the Oceanic and had his own commercial fishing boat named after the hotel.

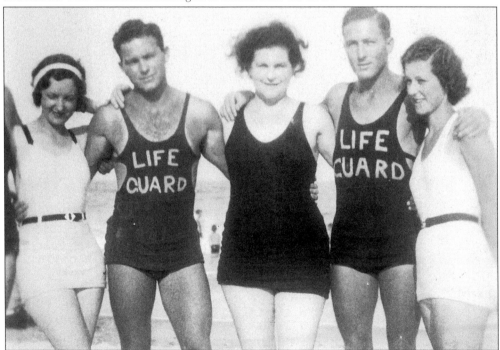

In a photo they labeled "100% Family," Lina, Relmon, Geneva, Earl, and Elberta Robinson pose at Wrightsville Beach, about 1935. After his own days as a lifeguard, Relmon became a popular coach at New Hanover High School.

Albert Creasy (left) and Bill Creasy (right) sit with their grandmother, Mary Lena Kelley, in August 1937. The hand-lathed lattice work behind them, once common at Wrightsville Beach, was crafted long before lumber companies began selling it in ready-made sheets. (Bill Creasy.)

Lina Robinson Hursey (left) and friend Mrs. Barbee were photographed at Wrightsville, January 7, 1923. At the time, it was rare to see anyone, especially well-dressed women, on the strand at Wrightsville Beach in the winter. (Silvey and Cecil Robinson.)

Margaret G. Banck and her aunt, Augusta Gieschen Fick, were photographed near the Hanover Seaside Club in 1921. Margaret Banck, a 1938 graduate of Duke University, worked 47 years as a medical technician for several revered Wilmington physicians, including Joe Hooper, George Johnson, William Wienel, John Ormand, and Andrew Cracker.

Author Boyden Sparks made his summer home at Edgewater, on Airlie Road, from 1934 until his death in 1954. Among his other achievements, he was a regular contributor to the *Saturday Evening Post*. A number of famous people visited Sparks, but you can believe Robert Ripley was the only one who sailed to Wrightsville Beach on a Chinese junk. (Lower Cape Fear Historical Society.)

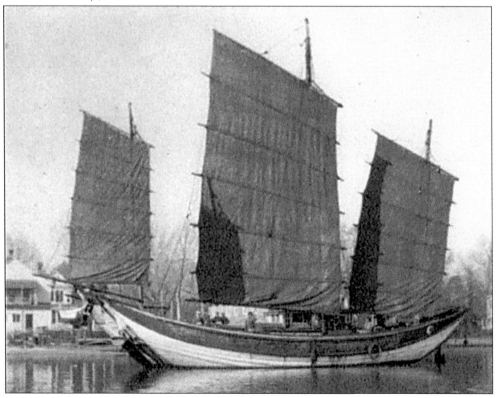

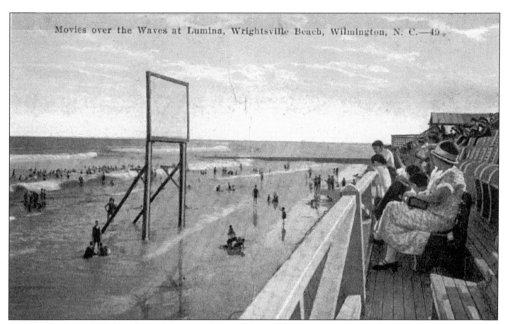

Paying Lumina visitors, like those on the right, could sit high and dry and view silent movies shown over the ocean at night. But down on the strand, it was easy to lose track of the tide when the feature started rolling. Under Lumina, stacks of Coca-Cola crates and a few surreptitiously hung hammocks made pilfered viewing more comfortable. (Lower Cape Fear Historical Society.)

Young Michael Brown relaxes on the boardwalk in front of Lumina in 1919. Brown, the grandson of early beach resident Michael Corbett, later became mayor of Wrightsville Beach (1954–1955) and city executive for North Carolina National Bank. (Brown-King.)

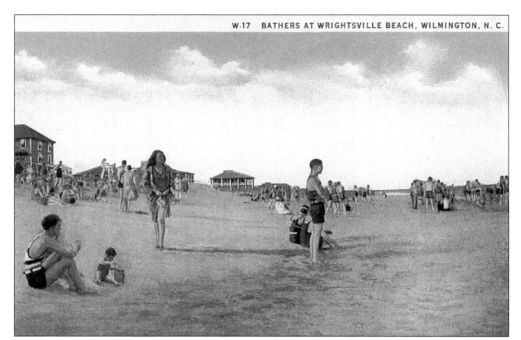

In the 1920s, the strand was still wide, but houses on Ocean Avenue (house far right) were awash with every northeaster. Homeowners like Cape Fear historian Louis T. Moore (1885–1961) saw their cottages wash away in 1933. If they could have lasted one more year, the fire of 1934 would have destroyed them—and precipitated an insurance check. (1999.51.1.)

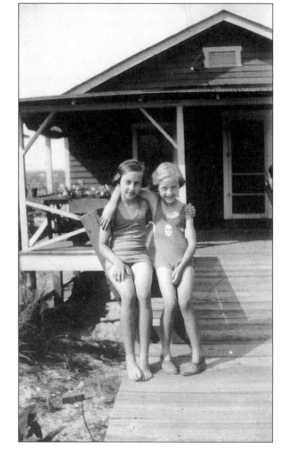

Sisters Grace (on left) and Beth Slocum, photographed about 1929, enjoyed their family cottage on Augusta Street. Getting there meant a trip on the elongated beach car to Station One, then a short ride on the "Sandspur," a standard size trolley that went from the Oceanic north to Salisbury Street. (1997.82.1.)

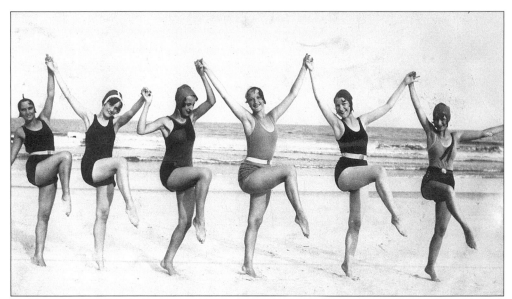

The Roaring Twenties brought about more change at Wrightsville Beach: there was an increase in organized events and a decrease in bathing suit fabric. Here, six young women kick up, about 1927. (New Hanover County Public Library.)

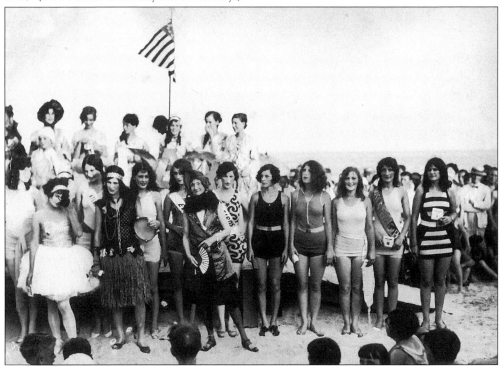

The Feast of Pirates (1927–1929) was a ribald festival dedicated to "mindless merriment." Many of the events took place at Lumina, including this beauty pageant. Staged in the days before body sculpting beachwear, it was hailed as the showcasing of "bewitching mermaids on Wrightsville's shimmering sands." The woman in the foreground is Mrs. Cuthbert Martin, an official propriety enforcer at Lumina. (Lower Cape Fear Historical Society.)

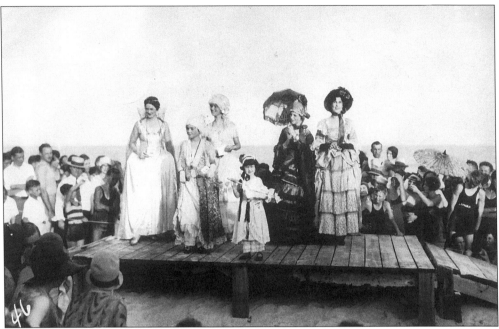

The 1928 Feast of Pirates celebration included a "Period Costumes Contest." Entrants assembled in the Tea Room of the Oceanic Hotel and paraded to Lumina, where judges viewed them on the boardwalk, seen here. (Lower Cape Fear Historical Society.)

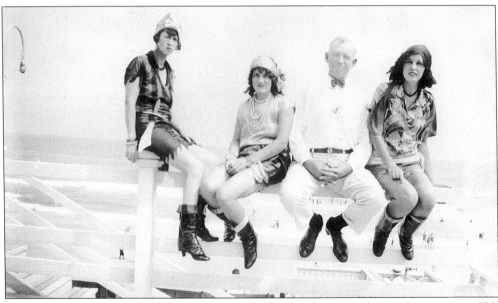

Three pirate girls and a Feast official take a somber break on a railing at Lumina, in 1928. Hilarity reigned, however, at the festival's most popular beach event: the Humbug Circus at Lumina. The highlight was a ballet performed by a corpulent gentleman named Walter Yopp Jr. and a slender man named Richard Meier. Dressed in garish colored tutus and their own street shoes and sock garters, they pirouetted as the crowd roared. (1987.23.4.)

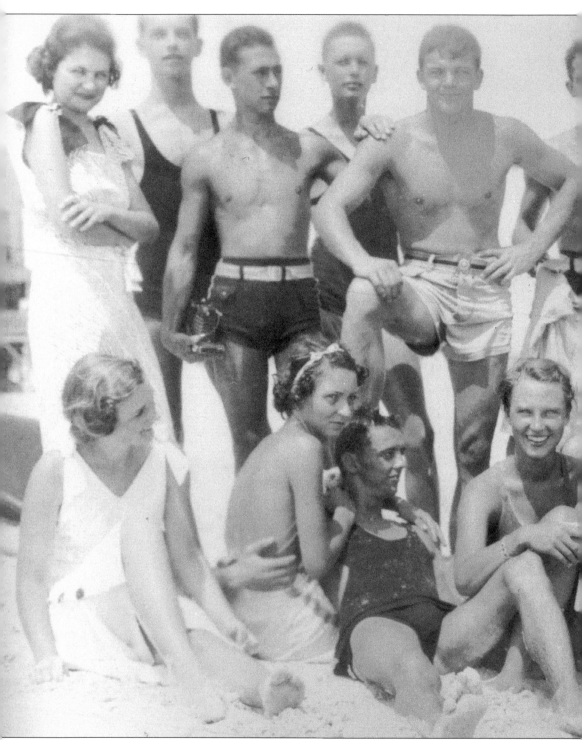

This photo, taken about 1933, includes the following, from left to right: (bottom row) Mary Sibley, Margaret Graham, Michael Brown, Elizabeth Whitehead, Catherine Alexius, Rosalie Watters, Agnes Peschau, Jimmy Carr, and Adair McKoy; (top row) Eleanor Wright, Tom

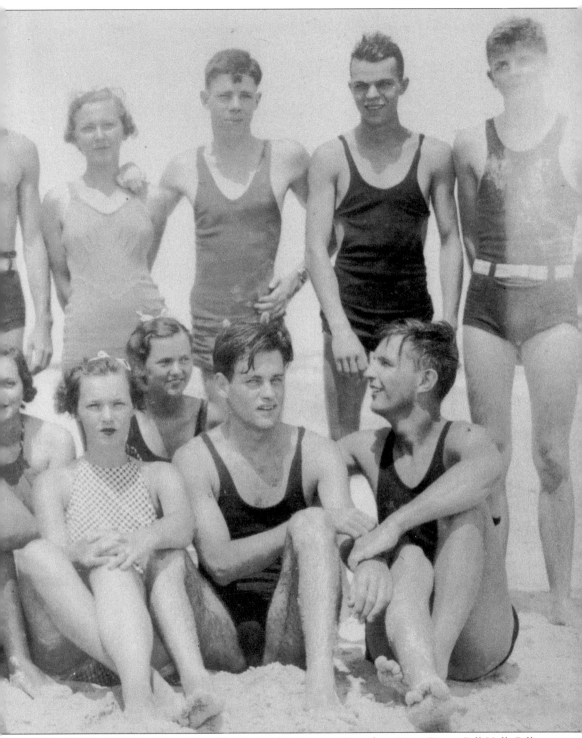

Wood, John Schiller, Harry Stovall, Van Webb, Garnett Saunders, Mary Berry, Bill Hall, Bill Howard, and Alexander Hall. (Brown-King.)

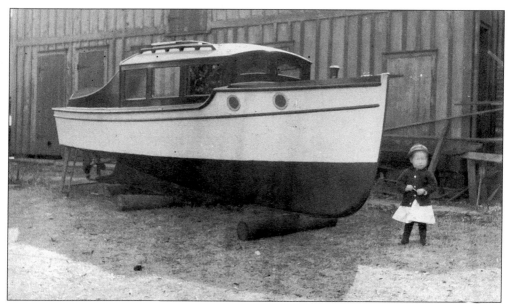

The boat was designed and built by W.R. Hartsfield of Wilmington, about 1919. Photographer George Nevens was fascinated with trains, boats, and planes. He took these four pictures (pages 52 and 53) at Wrightsville Beach between 1918 and 1929. (1988.39.338.)

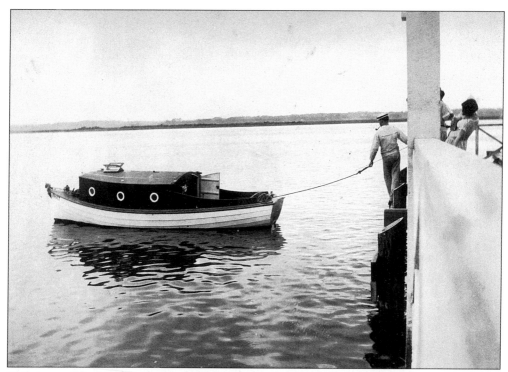

This is possibly Captain Arthur Butts, a popular skipper who had a boathouse on Banks Channel. Although he was known to buy expensive boats, he was also famous for sneaking peeks at Lumina movies from under the pavilion. Eventually locals came to know the free seats in the sand as "Butt's Theater." (1988.39.289.)

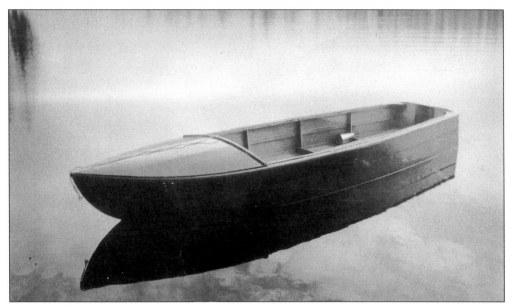

This little beauty was made by Wilmingtonian Julius Herbst about 1920. Herbst Boat Works was located between Burnett Boulevard and the Cape Fear River, near Southern Boulevard in a building once used for World War I shipbuilding. (1988.39.283.)

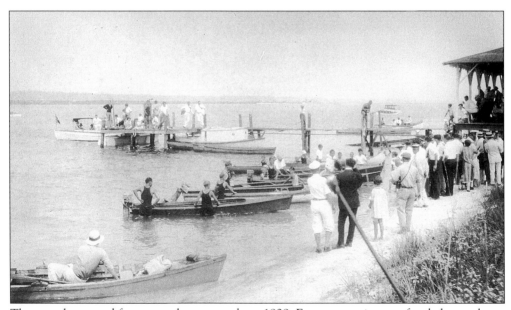

The crowd prepared for a motorboat race, about 1929. For some, noisy, newfangled motorboats were something to fume about. "Back then, the inside of the beach buildings was about the same as the outside—just some boards in between," said Katherine Meier, who attended the Catholic church. "Father Denning used to get so mad." (1988.39.298.)

Though usually associated with Carolina Beach, the Freeman family, legendary fishermen from Seabreeze, were at Wrightsville Beach when these photos were taken. Boatbuilder Julius Herbst and Edgar Freeman take a ride in a new boat, about 1920. (1988.39.273.)

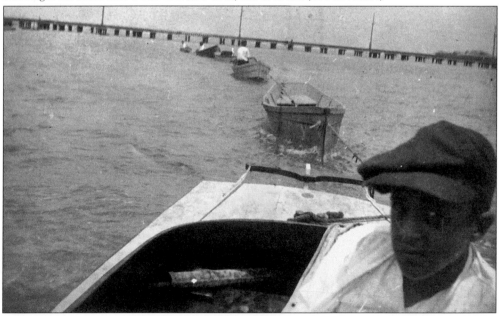

Edgar Freeman, in a motorized boat, pulls the rest of his fleet through Banks Channel. The Harbor Island pavilion is visible on the far right. (1988.39.271.)

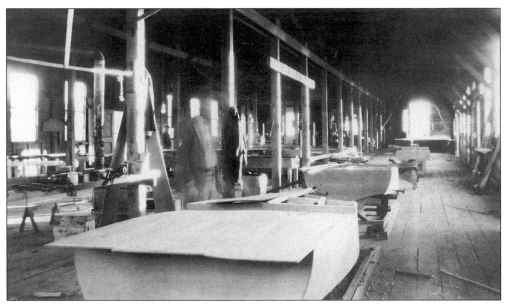

Many gifted boatbuilders have called Wilmington home, including W.R. Hartsfield, Julius Herbst, and T.N. Simmons. This photograph was taken inside Herbst Boat Works, about 1919. (1988.39.341.)

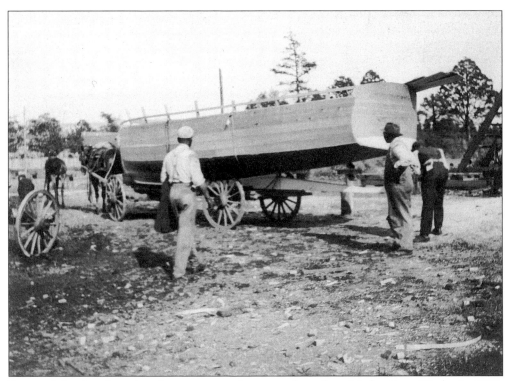

Power of the four-legged variety transported new products from Herbst Boat Works, in 1919. The vessel's frame was made of white oak with cedar planking, and it had "just a little over 4,000 brass screws in the bottom." (1988.39.265.)

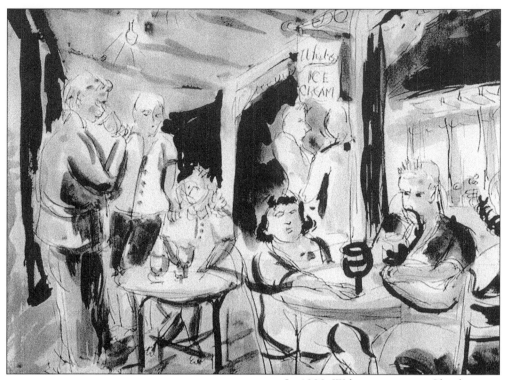

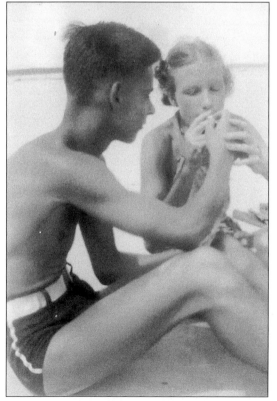

In 1938, Wilmington artist Claude Howell drew his own version of Pop Gray's sidewalk cafe at Station One. To the right is Bud Werkhauser's Stand at Station One, where beachgoers could purchase newspapers, souvenirs, and cold drinks. Beach water was horrid in those days and cold drinks or spring water transported from Greenfield Lake seemed a necessity. (Private collection.)

That same year, Claude Howell was photographed at the Carolina Yacht Club, lighting up with friend Cynthia Anderson. "We practically lived at the yacht club," he wrote in his journal, years later. His observations of area beaches were transformed into a steady stream of artwork that gained national attention. (1997.55.465.)

Wilmingtonians Allan T. Strange and Dan D. Cameron (holding Sigmond Bear's dog, Peggy) relax at Wrightsville Beach, about 1930. (IA4799.)

Nancy Crow treads the boardwalk "street," about 1929, leaving Bud Werkhauser's Stand. Luther Rogers, whose father was the leading builder at Wrightsville in the 1930s, said, "I remember when North Lumina was paved with concrete [1935]. We moved over to the beach before they took the tarps off." (Brown-King.)

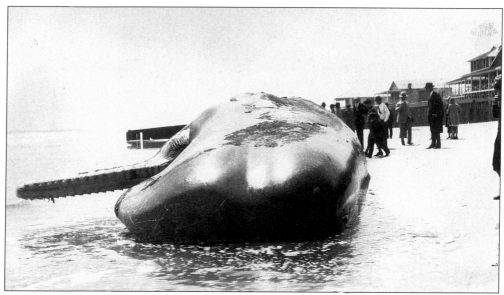

"Trouble," the whale that succumbed at Wrightsville on April 5, 1928, was the single most photographed local beach subject of the twenties. It seems that everyone who had a camera risked olfactory offense to snap copious pictures of the 50-ton carcass. An estimated 50,000 out-of-state visitors saw Trouble. The closest neighbor, M.M. Riley Jr., 54 Ocean Avenue, was relieved when officials of the N.C. State Museum contracted Luther T. Rogers and Cape Fear Towing Company to carry Trouble away. The first towing attempt failed and Trouble swept back onto the beach. Finally, they moved her to Topsail Island, where nature prepared her for a Raleigh debut in the Mammal Room. (1981.52.3.)

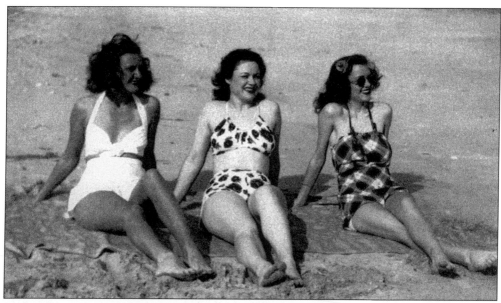

Annie Bryant Peterson, Katherine Meier, and an unidentified girl (from left to right) soak up sun at Wrightsville, sometime in the 1940s. (Katherine Cameron.)

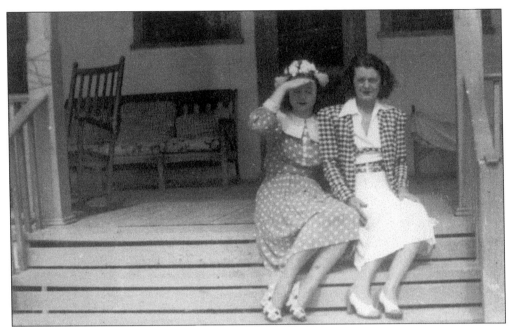

Katherine Meier and her mother, Beulah, were dedicated Wrightsville beachcombers. Katherine swam in Banks Channel before she could walk. Beulah Meier, owner of a fine dress shop in Wilmington, was such a smash in her white bathing suit, about 1919, that beach officials outlawed white bathing suits until lining them became customary. (Katherine Cameron.)

The Kitty Cottage, named for its poker tradition, was rebuilt after the fire of 1934. Here, at the rebuilt inn, a small group celebrates Wrightsville's proudest product. "Visitors can have fine sport out on the boundless ocean," reported the *Morning Star*, "provided they are ready to get up at 6 a.m." (New Hanover County Public Library.)

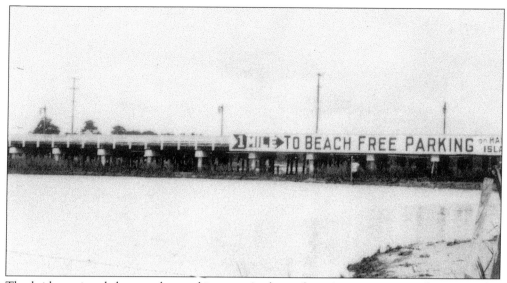

The bridge pointed the way, but parking wasn't always free. As a young man, future novelist Robert Ruark collected fees at the Harbor Island parking lot. He wove his experience into two books, *The Honey Badger* and *Poor No More*. In *Poor No More*, Ruark wrote of a main character's finding "a job parking and servicing cars on the island filling station between Kensington and the Beach. It paid him ten dollars a week and it was comparatively easy to knock down another five dollars from the parking receipts." (Lower Cape Fear Historical Society.)

Sisters Marguerite (on left) and Mary Barroll posed at 315 South Lumina Avenue, outside the cottage owned by their maternal grandfather, John D. Bellamy. The two girls and their other sister, Lewie, were raised in Europe and usually dressed in matching outfits. (Suzanne Joyce.)

Three
GOLDEN BEACH

The doors might have had locks, but the keys became rusty from disuse. Wrightsville was a friendly beach; people knew their neighbors and their parents had known the neighbors' parents. People were in and out of each other's houses and many of those dwellings were filled with visitors. Beach cottages have a way of creating new relatives.

Here, young members of the MacMillan and Williams families sit near Lumina on the Fourth of July, about 1915. (1980.45.38.)

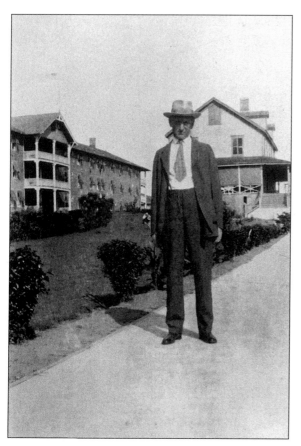

Emanuel Israel Bear had a summer house next to the Oceanic Hotel (seen on left), at 91 South Lumina Avenue. A handful of boys who were year-round residents, like Luther T. Rogers Jr., used to put water on his long driveway on cold winter nights and slide down the frozen slope the next morning. (IA4803.)

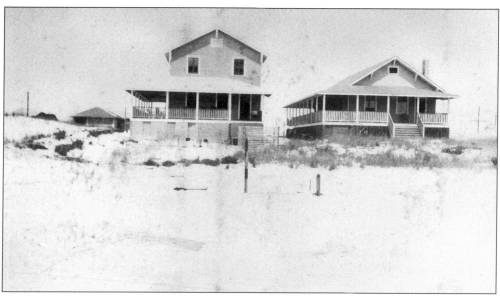

Next door neighbors, the Bears (house on left) and the Sternbergers (right) were relatives. Exterior and interior shots were taken by Henry L. Sternberger on August 4, 1934, soon after the house was rebuilt following the fire of 1934. (1985.72.19.)

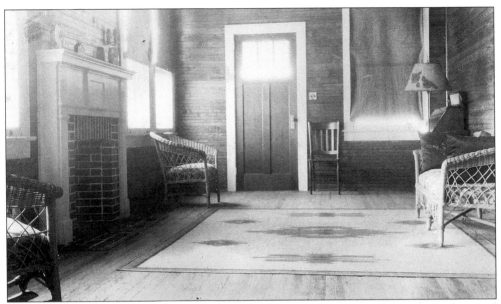

The interior of the Sternberger cottage typified many of the era. Dark wood paneling and wicker furniture prevailed. The fireplace is unusual though; at the time, most Wrightsville Beach homes were vacant after Labor Day weekend until Memorial Day. (1985.72.22.)

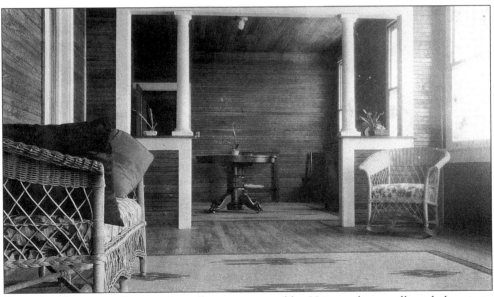

Smart builders omitted as much wall space as possible. Using columns allowed the air to circulate, an important thing before the days of central air. The only time in summer that a house was closed up tight was during periodic onslaughts of "no-see-ums," or sandflies. (1985.72.21.)

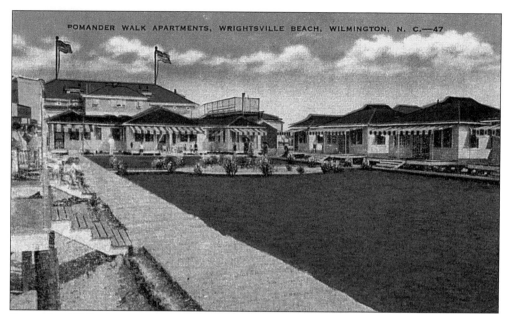

Pomander Walk, between Lumina and Banks Channel, was once home to young David Brinkley, who lived in an apartment on the left-hand side, in the early 1930s. Another resident, Mrs. Cecil Appleberry, lived on the right. She was famous locally for her extensive knowledge about wildlife, especially birds, and on summer nights, was part of a group of women who crabbed in Banks Channel using string, bait, and railroad spikes. (Bill Creasy.)

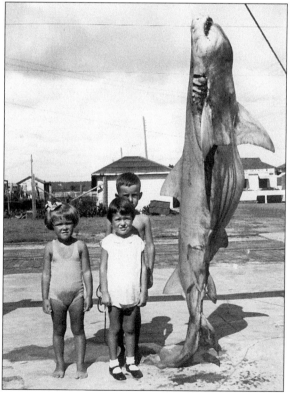

Edna Appleberry was suspicious one night, about 1935, when something swallowed both the crab bait and the railroad spikes. After local fishermen rigged up a heavy duty line at Pomander Walk, the dock and several small boats tied to it started rocking. The shark on the line fought so fiercely that only a rifle shot brought it in. Here, Thomas K. Appleberry poses with two unidentified girls and the catch of the day. (Bill Creasy)

Katherine Meier Baird performed one of her famous leaps at Wrightsville Beach, about 1937. The spectators are (left and right) Peggy Frownfelter and Katherine King. (1998.128.6.)

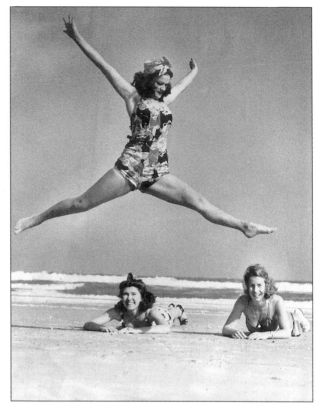

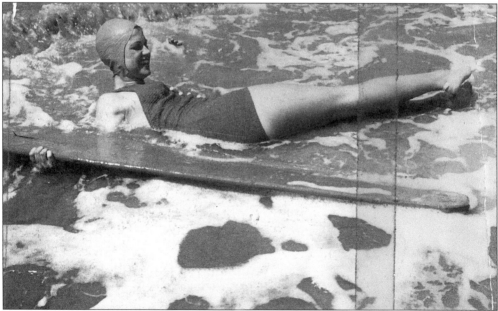

The N.C. Bureau of Tourism commissioned this 1937 shot of Katherine Meier holding on to a surfboard made by her father, Richard Meier. During that time, a sandbar ran the length of Wrightsville Beach. "Surfers" swam out beyond it and rode the waves back in, lying halfway on the board. (1998.128.8.)

Many who began to visit Wrightsville at an early age associate those sweet memories with thoughts of our parents. Our mothers mostly sat on the shore where they hugged, watched, fretted, tugged the backs of our wet bathing suits into decency, and wrapped us in big beach towels when we shivered on the sand. Our fathers worried less and spent more time in the water. They patiently pulled us around on floats and amazed us as they rode the big waves. In time, many of us take our own children to Wrightsville Beach, where, if caught in the day's last light, they look like sun-kissed angels.

Here, J. Laurence Sprunt locks fingers with his son, Jimmie, about 1918. (IA5144.)

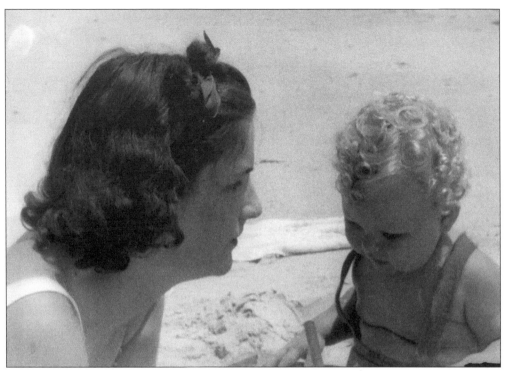

Virginia Bellamy Ruffin studies her daughter, Suzanne Nash Ruffin, about 1940.

Susan Walker and her mother, Frances Goldberg Walker, stand on the jetty near Station Five, about 1939.

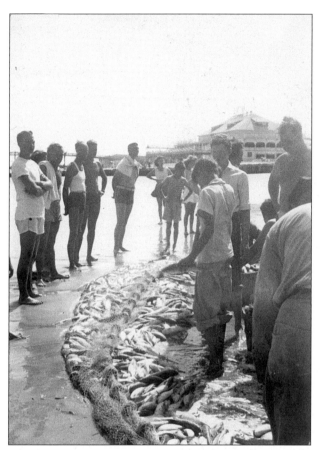

Photographer Barbara Marcroft caught a picture of this mullet run near Lumina in 1940. Life was still routine then, but a year later, World War II began and the beach changed. "You could feel the vibration when ships were hit, there were spies around—and so many blackouts. We left," said Verge Beall Emory, whose family moved off Wrightsville, during the war, for the first time in 20 years. (1997.43.203.)

Despite swarms of soldiers who moved to the beach, some routines were undeterred. William McKoy Bellamy, son of Congressman John D. Bellamy and an aficionado of cars and boats, rides in his outboard runabout, on Banks Channel, in 1944. (Suzanne Joyce.)

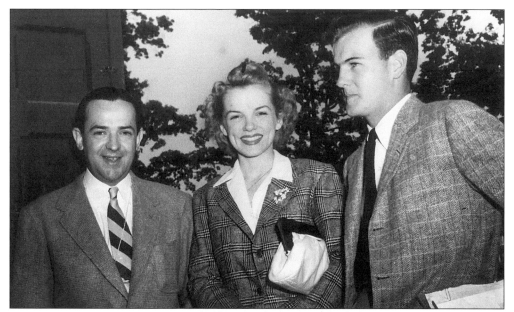

Big Band luminaries (left to right) Jimmy Dorsey and Helen O'Connell pose with Wilmingtonian Thomas H. Wright Jr. in 1945. Wright was the great-great-grandson of Judge Joshua Grainger Wright, from whom the name Wrightsville Beach evolved. Though Hugh Morton snapped this picture in Chapel Hill, all three spent plenty of time at Lumina. (1997.54.99.)

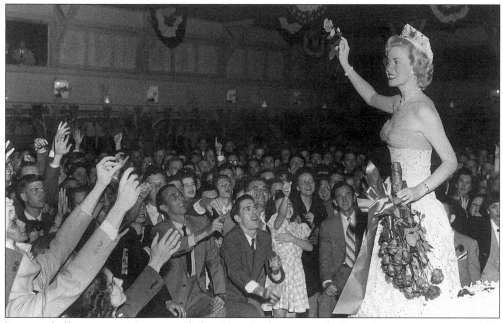

Lumina ballroom was the site of the first Azalea Festival Queen's coronation, in 1948. Jacqueline White tossed roses into the crowd and enjoyed an adulatory reception from her beaming subjects, but Beulah Meier, Hannah Block, and Willa Dickie labored hard to pull off a graceful event. "People worked themselves to death on those first festivals," said Katherine Meier Cameron. (Hugh Morton.)

She entered St. Therese Catholic Church, (1942), as Elizabeth Metts and emerged as Mrs. Michael C. Brown. Located at 209 South Lumina Avenue, the church stands on two oceanfront lots donated in 1895 by Mr. Brown's grandfather, Michael Corbett. Known originally as St. Mary by the Sea, the first building was a small frame church. Countess Kathleen Price of Greensboro donated a new structure in 1944 and requested the name be changed to St. Therese. The entrance was destroyed in Hurricane Hazel. (Brown-King.)

Michael C. Corbett was a wholesale grocer and president of the chamber of commerce from 1911 to 1916. His beachhouse, located at 407 South Lumina, was destroyed. However, his town house, 119 South Fourth Street, survives and was home to Miller-Motte Business College in the 1960s. (Brown-King.)

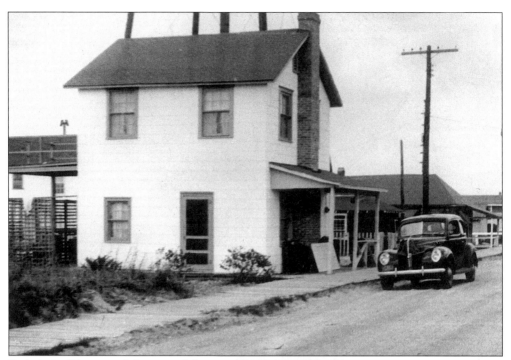

Early in its life, around the turn of the twentieth century, this house was a one-story maintenance office for the Tide Water Power and Light Company. It was sold during prohibition, and was facetiously named the "pest house," an old term for a quarantine hospital, when it became known as a place to get some whiskey. During World War II, Michael and Elizabeth Brown bought the building, added a second story, and lived there for ten years. This photo was taken about 1949. (Brown-King.)

In 1954, the Browns' two-year-old daughter, Elizabeth, eyed the camera as Rhoda Graham kept her in line. (Brown-King.)

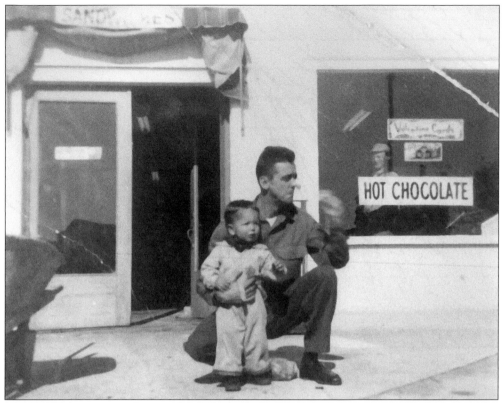

It looks like a scene straight out of the *The Andy Griffith Show*, but it's Station One, about 1950. Michael C. Brown and son, Mike, stand in front of Newell's Store. Lester Newell purchased Bud Werkhauser's stand before World War II and built a general store that endured, through several owners, into the 1990s. The building is now home to Wings. (Brown-King.)

At age 9, Juanita Lacewell sold seafood door to door at Wrightsville Beach for the family business: Everett's Seafood House. She started working at Newell's in 1949. Her first job was cleaning the old soda fountain, but soon she was promoted to clerk and then to merchandise manager. She worked there for 43 years, often performing intuitive matches of Newell's clothing to individual customers. Now retired, Ms. Lacewell still lives in the Greenville Sound area. (*Wilmington Star News.*)

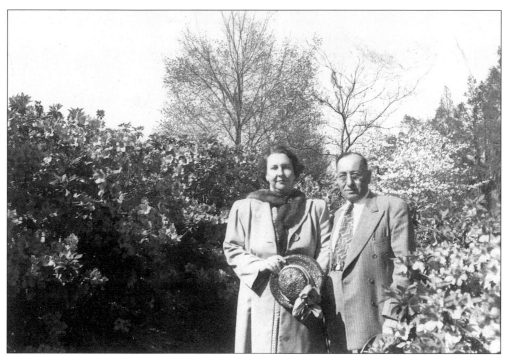

In 1944, Charles Roberts and his wife, Dorothy, enjoyed a spring day among the azaleas at Greenfield Lake, but usually they were minding the store. In 1925, Charlie Roberts, born Charles Robier, started Robert's Market in a wooden, live-in building with a restaurant, the Greasy Spoon, in the back room. He died in 1949, and Dorothy managed the market until 1973, when she sold the business. (Eva S. Cross.)

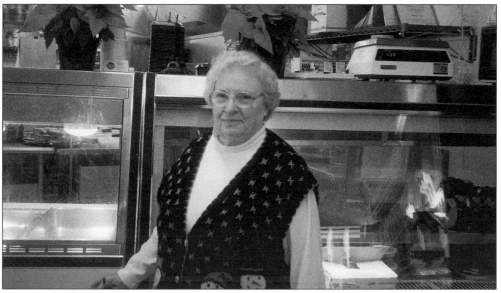

The Cross family now owns Robert's Market. Eva Sanders Cross, who went to work there in 1944, attributes her hearty work ethic to Dorothy Roberts. Mrs. Cross, who has trained several generations of young checkout girls, stock boys, and deli workers, still works a 70-hour week and keeps the help on their toes.

L.P. Grimes worked for the City of Wrightsville Beach in the 1950s. He assisted the police force, fire department, and longtime city clerk Rupert Benson. (Earl Jackson.)

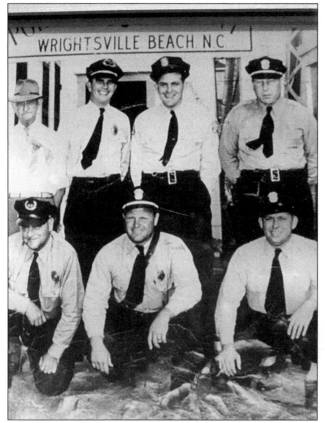

Wrightsville's finest posed in 1947; they are, from left to right, as follows: (bottom row) Fred Futch, Buck Mabory, and Dennis Conner; (top row) Mr. Womble, Riley Wiggs, Mr. Anderson, and William Cross. (Eva S. Cross.)

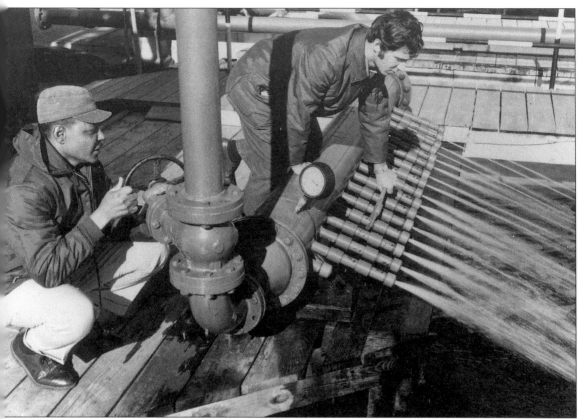

Earl A. Jackson (pictured above, on left) grew up close to Wrightsville Beach. His parents worked for Pembroke Jones and Henry Walters at Pembroke Park and at Airlie. Earl, as a young man, worked at Wrightsville Beach and had several different jobs in the 1940s.

During the 1950s, Earl Jackson was the beach's entire animal protection department. "I thought of myself more as a dog protector than a dogcatcher. I didn't want to upset the kids by taking their dogs. I kept some long ropes in the back of the car and gave them to kids as leashes. Most of the dogs knew me. I didn't have to get out and pick them up—I'd just snap my fingers and they'd jump in the truck. Mayor Michael Brown's dog used to ride shotgun in the truck when I made my rounds."

In the 1960s, Earl Jackson left municipal work to become a research technician at Wrightsville's International Nickel Company (pictured above), where he worked until retirement age. Currently, he is chaplain and maintenance overseer at the New Hanover County Jail.

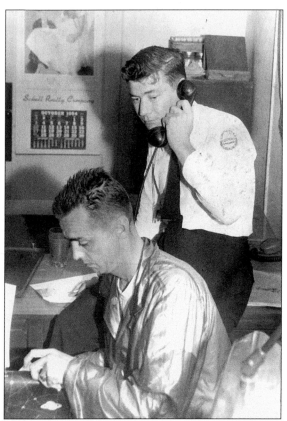

"The wind blows so hard, the ocean gets up on its hind legs and walks across the land." The line came from the movie *Key Largo*, but it belongs to every oceanfront community that has ever fallen victim to a hurricane. On October 15, 1954, Hazel, a fearsome animal, moved across Wrightsville Beach. Here, Mayor Michael Brown and Police Chief H.E. Williamson make preparations, aware that Hazel was no garden variety storm. (Brown-King.)

According to Ann Hewlett Hutteman, author of *One Hundred Golden Summers*, Hurricane Hazel destroyed the first floor of the Hanover Seaside Club, tore off the roof, and weakened the rest of the 1906 clubhouse, located at 601 South Lumina Avenue. Pilings from the Luna Fishing Pier broke away during the storm and acted as battering rams, intensifying the damage. (Hanover Seaside Club Archives.)

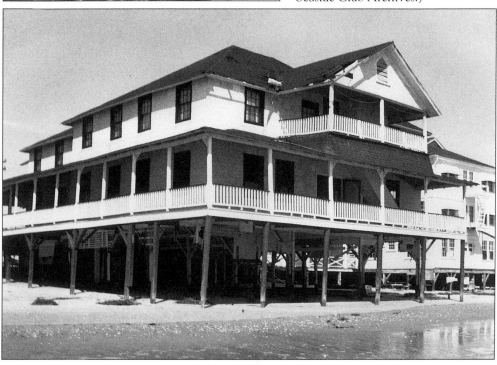

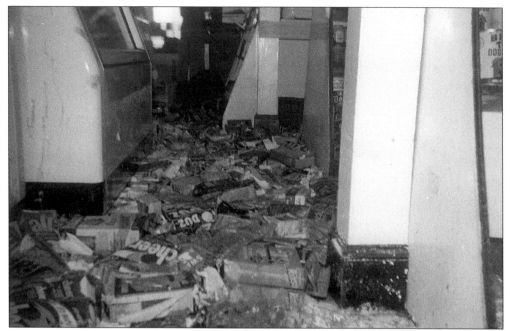

Hazel destroyed the contents of Robert's Market. Owner Eva Cross evacuated in plenty of time and returned to clean up, undaunted. "I've always treasured my life above any other possessions I have. Groceries can be replaced." (1996.60.2.)

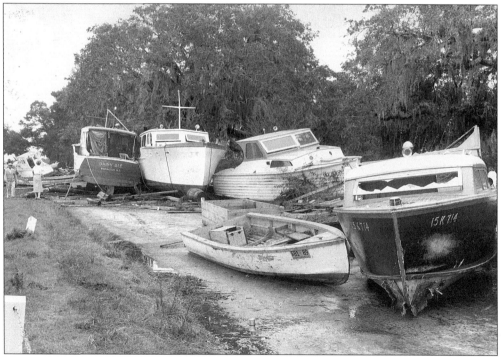

Hurricane Hazel transformed Airlie Road into a marina of horrors. Not only did it pack the greatest storm surge in Wrightsville's recorded history, it struck under a harvest moon. (Barbara Marcroft.)

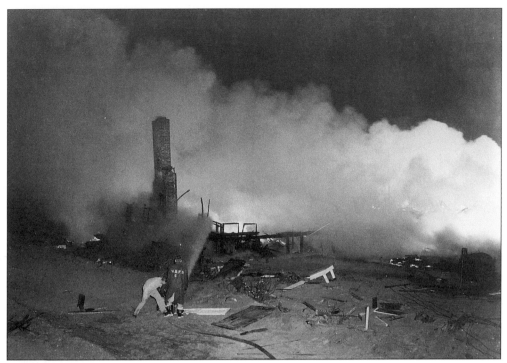

Hurricane Hazel damaged the Ocean Terrace Hotel, but a fire of unknown origin cleared the wreckage a few months later. Wilmington native Hugh Morton took this photo. "I got there late, but things were still smoking," he said. (North Carolina Collection, UNC.)

Lawrence Lewis Jr., with some prodding from Michael C. Brown, purchased the land and in 1964, replaced the Ocean Terrace with the Blockade Runner Hotel. Lewis was the son of Louise Wise Lewis and the great-nephew of Mary Lily Kenan Flagler. (William Baggett.)

Captain Eddy Haneman, seen here with son William Paul Haneman, in 1962, was famous for his manners and his dress. Operating from his charter boat, the *Martha Ellen*, he always seemed to know where the fish were biting and didn't mind sharing his knowledge. Captain Eddie died in 1994. William Haneman lives in Ireland, where he is an executive with Sun Microsystems. (Mary Robinson Haneman.)

The Wit's End, located at 8 North Lumina Avenue, was a popular bar during the 1950s and 1960s. This 1967 photo depicts artist Claude Howell, Jane Brady, John Brady, and Patty Minser (from left to right) enjoying a happy hour together, in a time before pop-tops. (Wrightsville Beach Museum of History.)

Annie Bryant Peterson, pictured here in 1967, moved to Wrightsville Beach in 1941. Within a few years, she had established her own realty company, now run by her nephew, Bob Bryant. "We were just a bunch of beachcombers down here," she said, remembering the early days when she put her Christmas tree on the strand and decorated it with shells. (Wrightsville Beach Museum of History.)

Naomi Yopp grew up near Greenfield Lake. She remembers the old mill and the day the lake froze over. As a child, she took frequent summer trips to Lumina on the beach car, but didn't care much for the "scented" water at the bathhouse. In 1940, her mother built the Glenn Hotel, near the pavilion. Ms. Yopp, pictured here in 2000, still runs the family business.

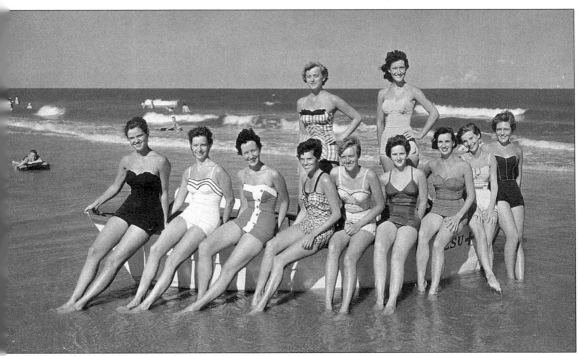

These girls posed for a postcard, about 1955. Jack Loughlin published the shot with the accompanying caption: "Would you like to be a lifeguard at Wrightsville Beach?" (1982.98.1.)

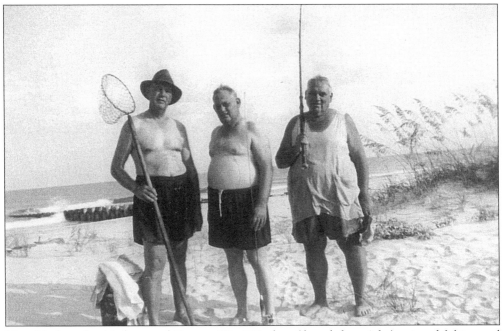

Marx Nathan, Joe Nathan, and Simeon "Doc" Nathan (from left to right) enjoyed fishing and crabbing near Crystal Pier. This photo was taken about 1949. (Reid Nathan.)

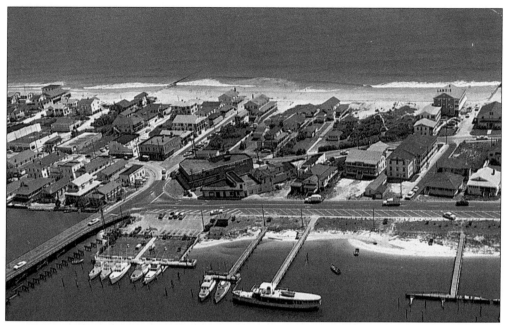

Before the Station One condominium was constructed, the neighborhood still looked more like a village. The old trestle is visible to the right of the bridge. (1999.139.1.)

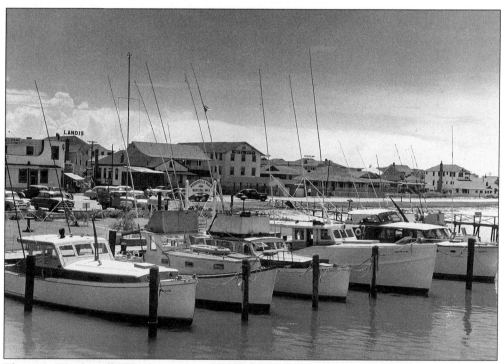

The new Wrightsville Beach Municipal Dock looked good in the 1950s. An earlier one was demolished in a 1944 storm. Beach mayor Jakie Taylor and commercial fisherman Eddie Haneman pushed for a new dock, tired of tying boats up to the old trolley trestle. (Lower Cape Fear Historical Society.)

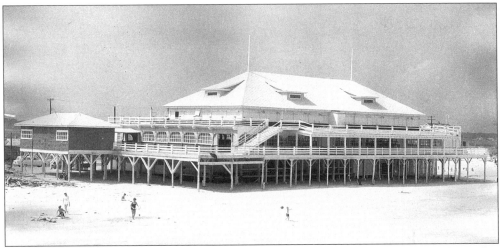

In the days when visitors carried flasks to Lumina, the building on the left was a chasers bar with a line like a busy cafeteria. By the 1960s, it was connected to a covered portion of the porch to create the Upper Deck, a popular bar. However weathered it appeared, the building remained solid and the natural acoustics of the band shell were still awesome when it was razed in 1973. (Lower Cape Fear Historical Society.)

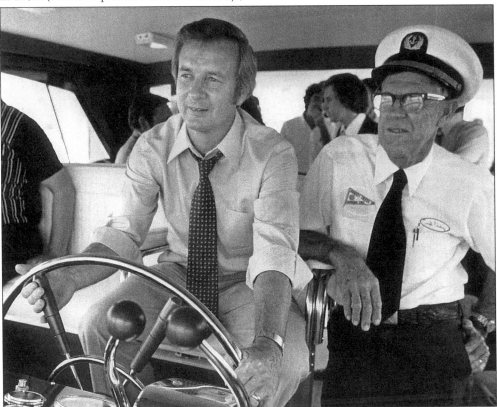

Governor James B. Hunt, under the watchful eye of Captain Eddy Haneman, took a turn at the wheel of Gene McWatty's boat, in 1978. McWatty, co-owner of S & G Concrete, built Bradley Creek Marina. (Mary Robinson Haneman.)

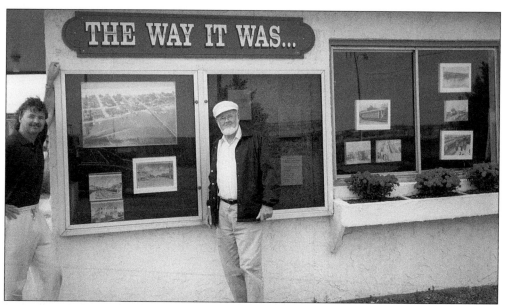

First museum director Greg Watkins and resident beach authority Bill Creasy pose in front of the first Wrightsville Beach Museum of History, located at Wynn Plaza, about 1990. Today the museum is housed at 303 West Salisbury Street, in a relocated vintage cottage, under the direction of Linda Honour. (Bill Creasy.)

The Wrightsville Beach house of James Moss Burns Jr., at 532 South Lumina Avenue, sports distinctive relics from other houses. The gate once stood at Dr. Owen Hill Kenan's house in Paris but was shipped to the United States to avoid meltdown as World War I scrap. The balustrade came from Pembroke Jones's hunting lodge.

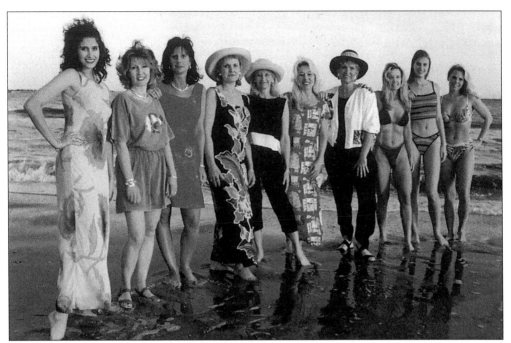

The old dress codes gave way long ago. These women, wearing an array of Wrightsville Beach clothes, posed for photographer Marshall Morgan in 1999. (Pamela's Fashion for Fun.)

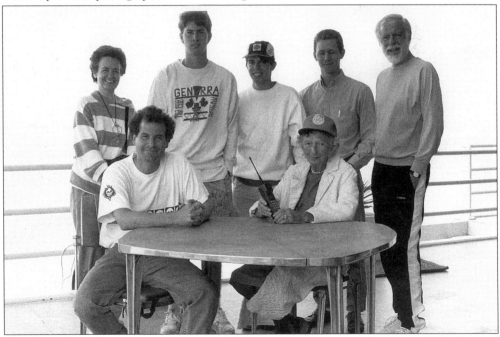

Crew members from the 1991 motion picture *Sleeping With the Enemy* posed with philanthropist Tabitha Hutaff McEachern (in Sundrop cap) on the set, at the north end of Shell Island. The Hutaff family, once major distributors of Coca-Cola and Sundrop, owns the southern tip of Figure Eight Island, or the northern tip of Wrightsville Beach. As Mason's Inlet shifts, so does the Hutaff tract.

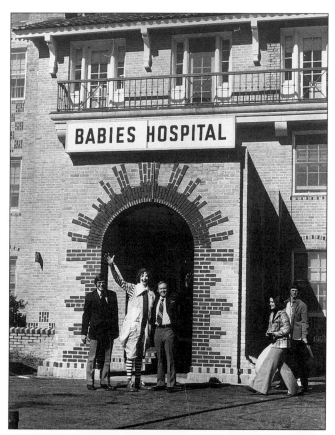

Though the first children's hospital at Wrightsville was built by James Sprunt, Dr. James Buren Sidbury founded Babies Hospital in 1920. In 1974, when this photo was taken, it was housed in a picturesque building that still stands on Wrightsville Avenue, near Summer Rest Road. Here (left to right) Don Betz, Ronald McDonald, and local McDonald's franchise owner Dennis Anderson signal a corporate donation of pediatric hospital equipment. (1982.40.59.)

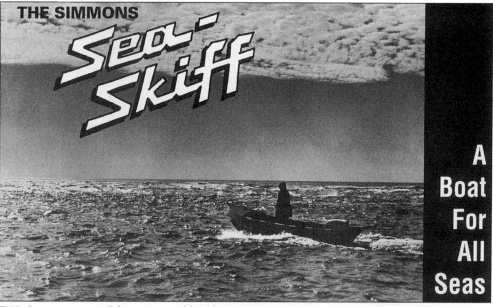

THE SIMMONS Sea-Skiff

A Boat For All Seas

T.N. Simmons started designing and building skiffs after he left the Wilmington shipyard at the end of World War II. Their durability and Simmons's knack for customizing quickly made them a local favorite. In 1966, he and his son, T.N. Simmons Jr., built and delivered 46 boats.

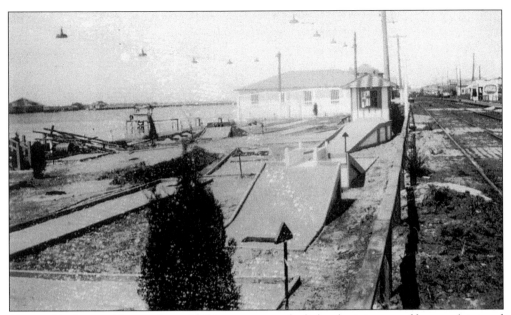

George Clark, an avid canoeist and fisherman, created a lighted miniature golf course (pictured here) between the Seashore Hotel and Banks Channel about 1920. In June 1930, the Oceanic followed with its own Tom Thumb Golf Course. (George T. Clark Jr.)

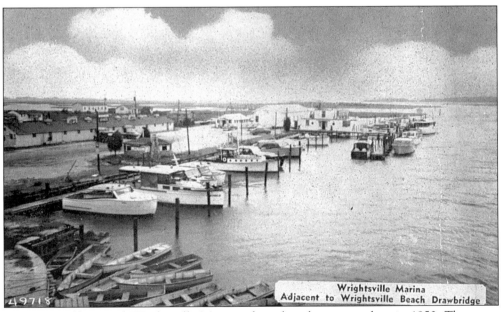

Wrightsville Marina
Adjacent to Wrightsville Beach Drawbridge

Gene Reynolds owned Wrightsville Marina when this photo was taken in 1950. There was some grumbling among the boat owners when slip rental fees rose to $30 a month.

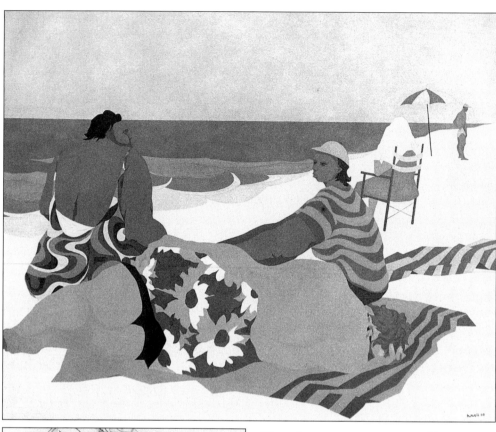

These four pictures were created by Wilmington artist Claude Howell (1915–1997), who began drawing beach scenes in his youth. In time, other artists applauded when his work became more stylized, but lots of sentimental locals missed his early "recognizable" paintings. *Bathers* was done in 1968. (1997.55.600.)

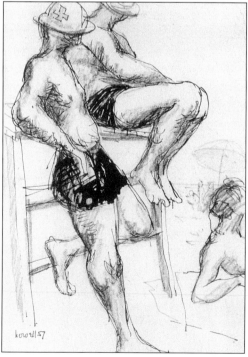

Howell executed this drawing, *Lifeguards*, at Wrightsville Beach in 1957. (1997.55.599.)

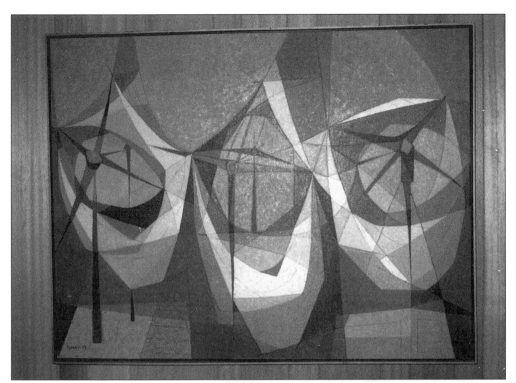

Drying Nets typifies many of Howell's works in the 1960s. He was fascinated with every aspect of fishing and spent hours re-creating the process. But, oh how surprised area fishermen must have been to see the other side of his easel. (1997.55.600.)

In *Farmer's Picnic*, though painted in 1968, Howell called on his personal memories of Lumina. (1997.55.600.)

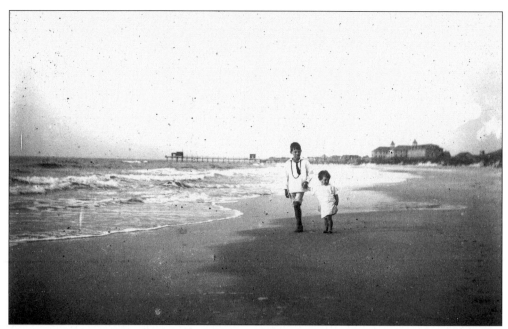

Henry MacMillan and his little sister, Helen, vacationed at Wrightsville Beach and lived in the house their grandfather, William A. Williams, built at 118 South Fourth Street in Wilmington. Both children grew up to be artists. This photo was taken by their grandfather about 1918. (1980.45.33.)

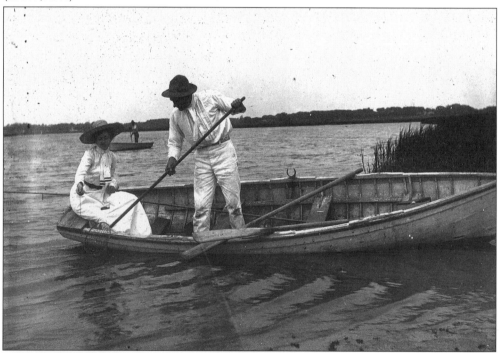

Eric Norden and his wife, Laura Howell Norden, enjoyed the waters of Wrightsville Sound, their backyard. He amassed one of Wilmington's most valuable rare book collections, only to lose it, along with their home, in a fire about 1938. (1980.36.74.)

Four
ANOTHER EXPERIENCE

. . . like a circle in a spiral, like a wheel within a wheel . . .
—Windmills of the Mind.

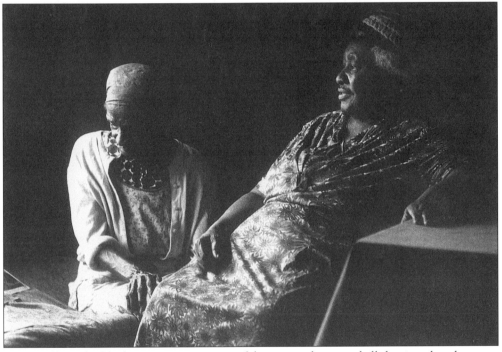

Historically in the black community, meaningful moments happened all the time, but there was seldom enough money to develop film, let alone buy a camera. Still, vivid memories survive that help form pictures of another world within area beaches and Wrightsville Sound. During segregation, blacks were set apart, yet were an intimate part of white family life.

On the beach, there were few exceptions. Though not allowed to swim during daylight at Wrightsville Beach, a black "nurse" would spend all day caring for white children, often resulting in tender two-way loyalties that would endure for a lifetime. Domestics often knew more about a white family than did the next door neighbors.

We found some wise souls who remembered the beach and the sound in the old days. Their words paint pictures that all the cameras missed.

Minnie Evans and her mother, Ella Kelly, were photographed by Harry Knickerbocker, about 1970. (1981.1.18.)

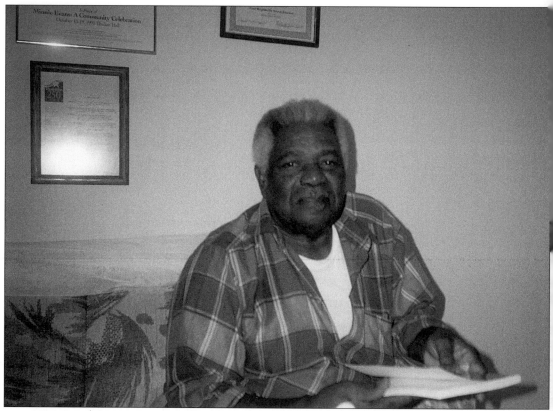

George Evans, son of artist Minnie Evans, is pictured here in 1999. He remembers going to Shell Island with his father, Julius. "Shell Island belonged to the blacks. When I was a little boy, my daddy used to take us over there. An inlet divided Wrightsville Beach and Shell Island. You took the ferry and there was a boardwalk from the dock to the buildings. I remember when that thing burned down."

Evans grew up on Wrightsville Sound where his mother and father worked for Sadie and Pembroke Jones, and, later, for Sadie and Henry Walters. When he was a boy, he and his family lived in the caretaker's house in Pembroke Park, now known as Landfall.

"Pembroke Park: that's where I was born and raised, about a block and a half from the big house [the Lodge], in the servant's house. There were fish ponds. Each of the four had a different kind of fish. We had to clean that place out once a year. It was a beautiful thing. It was a big pond; they had a fountain sitting right in the middle of it.

"There were servants quarters downstairs and one on the west side of the house. I'm sorry that place burned down. That place should have stayed there. It was the most special place you'll ever see in your life.

"Sometimes when I was a boy, I'd go into Wilmington and stay at the Bijou theater all day long watching Hoot Gibson and all those crazy guys. I'll tell you there were some people back in those days. Shoot all day. Never stop to load or nothing. Just shoot all day.

"I was just a boy when Pembroke Jones died. He had many horses and the carriages and he was a jolly man. He loved people. Loved to go around shaking hands with people. During Christmas time he would have his horse and buggy all dressed up and he would go all around through the neighborhood singing and all that kind of stuff.

"Later on, Sadie Jones married Mr. Harry Walters. She owned Airlie then and she just kept developing and developing and developing. Oh my goodness that was some place. They had an indoor tennis court there and they also had a clay tennis court at Pembroke Park, years ago.

92

I never knew Mr. Walters to play tennis though. He was an old man then and he had gout. He was quite up in age when he got married. He had a white goatee. He was a nice old man. Very nice.

"They had parties, I'm telling you all kinds of parties. The older Sprunts, Rountrees, Jessie Wise, and her sister, Mrs. Kenan, and the Dicks, the Bolles, the Bacons, all that crowd, they're gone now.

"I was Mrs. Walters's footman. She employed so much help that she used to laugh and call herself 'The Mother of Wrightsville Sound.' I would go around with her at Airlie and places when she took out the horse and buggy. She drove herself all over the garden. She had a little dog that she got a few years before she passed, a little poodle named Mack. He was the devil. He'd grab at you and bark and she'd say, 'Mack shut up!'

"When the Corbetts bought Airlie, they asked my mother to be the gatekeeper. They also hired my daddy to be the 'Old Man of Airlie.' He just walked around and he had a high hat and wore a coat and just walked around the garden to see people and laugh and talk with them. Everybody loved Julius. Everybody thought the world of him. As far as work, he didn't do anything, he was just the 'Old Man of Airlie,' that's all."

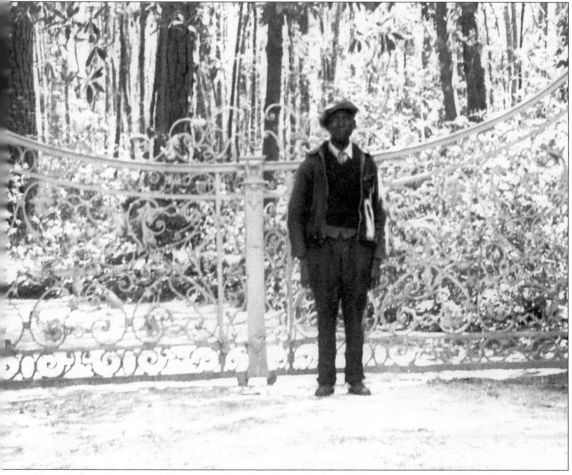

Here, Julius Evans stands against the backdrop of the Airlie gates, about 1949. (Barbara Marcroft.)

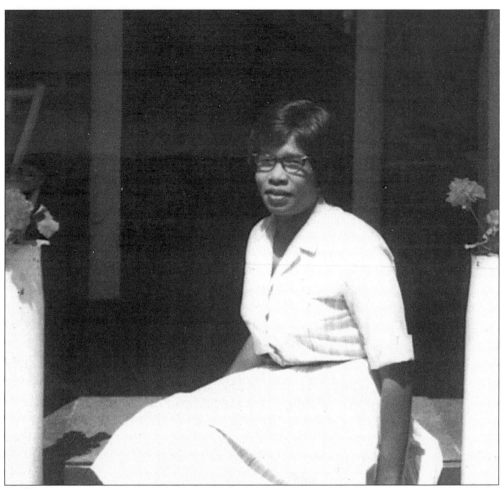

Georgie Hurst Franks, pictured here about 1958, has always lived near Wrightsville Beach. She reminisced in 1999 about her life on the sound and at Wrightsville Beach. "I grew up off the Shell Road, near Airlie. When the chain-link fence was up over the road to Airlie house, we were told we could play along the lane. When it was down, that meant Mrs. Harry Walters was in residence and we had to stay away. Well, one day when the chain was down, I was playing away from the road and looked over and saw a snake about to eat a bird. I grabbed a stick and was prying the little bird out of his mouth when I heard a deep voice say, 'Little girl, little girl, what is the matter?'

"It was Mrs. Walters. I had forgotten to stay out of the road because I was so interested in saving the bird and, by the time she spoke, George Evans had already helped her down out of the carriage. George used to dress like Johnny in the Philip Morris ads and he rode on the back of her carriage. When it was time for her to get out, he helped her down. George Evans is Minnie's son. Minnie and Julius Evans were caretakers for the Lodge and George and his brothers grew up over there at Landfall.

"I explained what had happened and I was sort of overwhelmed that I was talking to Mrs. Walters. She listened and then said, 'Well, you need to be careful. Snakes can be very dangerous.'

"That was all. That's my only story of Mrs. Walters, but it is my story.

"My grandfather was Albert Hurst. He was an oysterman and had a boat, a skiff, that he rowed over to Wrightsville to gather the blacks that worked on the beach and he'd carry them

over to Shell Island where they could go swimming. Then later, somebody built a pavilion and he would row people from the mainland over to Shell Island. Then later, blacks who had it better than some built houses there and he still provided transportation to the island. Then, all the houses and buildings burned and there were suspicions that it was no accident.

"Blacks couldn't go in the water at Wrightsville then unless you were a child's nurse and then you could only go in up to your ankles to watch the child. The blacks that worked at the Seashore and the Oceanic could swim in front of the hotels after dark.

"My first job was at Wrightsville Beach. During World War II when Camp Davis was set up, some of the officers went to the beach and I worked there, cleaning for them.

"My family, the Hursts, are buried under a condominium development. My husband's family, the Franks, used to own a lot of waterfront land on Greenville Sound. Then they just kept moving back as people would offer them money for the better land. The Franks are buried on that first road off Greenville Loop, the one with the big curve. My husband used to take me there on holidays with him to visit his parents' graves. Then one year we went and they were building a house on top of the family plot. There's lots of houses there now."

Georgie Hurst Franks, a 1942 graduate of Williston High School, retired recently after working 14 years at Babies Hospital and 35 years for the Howard Penton family. (Roi Penton.)

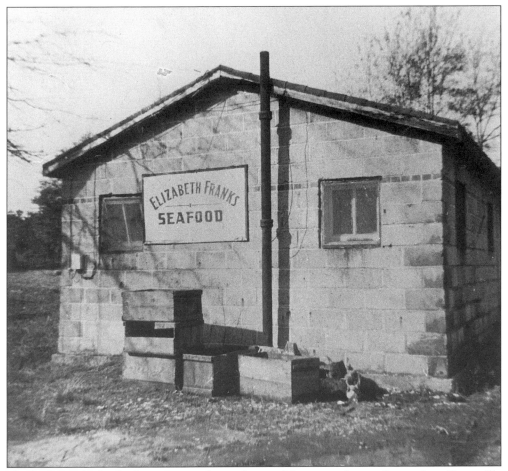

Elizabeth Franks Seafood was famous for marketing delicious crabmeat. Located on Greenville Loop Road, it supplied seafood to fine beach restaurants and Wilmingtonians who were "in the know." (Anne Russell.)

Mary Hargrove Fields's grandparents, Mr. and Mrs. Louis Bolden, were once part of Governor Dudley's work force. After the Civil War, the Boldens lived near the Cape Fear River adjacent to Sunset Park and, on Sundays, walked to St. Stephen's Church at 501 Red Cross Street. Mary Fields and her family have worked for Captain John Harper, Colonel Walker Taylor, Sprunts, Graingers, Bellamys, and Kingoffs. Born in 1905, Mrs. Fields still has vivid memories of the "National Negro Playground."

"Shell Island was a place we used to go for picnics and things. It was beautiful down there, but we used to have to go on the trolley and then take a boat to the island. Labor Day was the biggest day they had down there. People would come from different places. They didn't mind riding on trucks then. They would get a truckload of people and bring them in to Shell Island when there was something going on in the dance hall. Sometimes they would have a band of local boys. I went there in a nice cotton dress, with sleeves. I always wore sleeves. I had on high heel shoes for the dance and I walked around the island in them, too.

"We also went to Bop City at Carolina Beach on moonlit nights. They had a little nightclub down there and everybody was crazy about dancing. I rode in Margaret Green's boat many times." (Janice Kingoff.)

Clarence Jones, master gardener at Orton Plantation, went to Shell Island with his family when he was a young man. His sister-in-law, Virginia Jones, packed a picnic lunch every time, but they didn't go often. Getting there from Brunswick County was a chore in those days. Mr. Jones was associated more closely with the black resort at Seabreeze.

"I knew Bruce. I knew Roscoe. I knew all those Freeman boys. Most of the fish they caught on Fridays was headed for the Front Street Market. They would have them bunched up, pack them on a wagon in 'haul-sand,' and take them to town. They'd drive the mule all night long to get to Wilmington for Saturday morning. They'd sell them from a wagon, 25 cents a bunch. In hot weather, you had to get them early."

Frank Clarence Jones is pictured here in 1999 at the age of 91. His accomplishments as gardener at Orton Plantation have been highlighted in several magazines, including *Southern Living*.

The *Electra* was one of the last boats the Freemans used in their fishing business. It also doubled as Margaret Green's ferry, to carry guests from Seabreeze to Bop City. (1988.39.268.)

Hannah Nixon, a volunteer at Cape Fear Museum, remembers beach life decades ago. "My mother used to go to dances at Shell Island. She would get dressed up and her friend would make sure the horse had a fancy saddle and they would take the horse and buggy from Kirkland, near Porter's Neck, to the island.

"After it burned down, we would go to Bop City for picnics and dancing, under the bridge, on the north end of Carolina Beach. They had a part of the beach down there for blacks but they kept moving it over until they were kind of in a corner. Lincoln Hill owned it. We would ride to Bop City in Margaret Green's boat. When she was taking people from Seabreeze to Bop City, she'd put her cap on and she kept a shotgun down in that boat. Margaret Green was something.

"But it was my brother who really loved Wrightsville Beach. His name was Alexander Pierce. My Daddy bought three mules, one for each of his boys. Alexander wouldn't do like my other brothers. He would act like he couldn't plow and pretty soon we'd find his mule where he had tied it up someplace and Alexander had gone out to the road and caught a ride to Wrightsville Beach.

"He would get work there at Lumina or at the Seashore Hotel so he could go swimming at night. Black people couldn't swim in the day at Wrightsville back then—not unless one was manning a boat and fell in. But all the help could go in the water at night. They always had quarters at the beach for workers. They needed lots of help with all those big places down there."

Hannah Nixon is pictured here at Cape Fear Museum, in 2000. (Suesan Sullivan.)

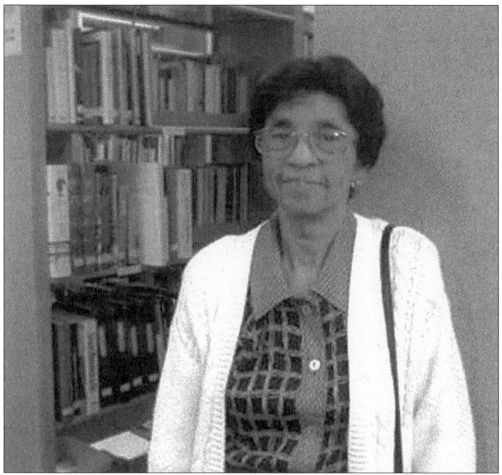

Katherine Ennett, also a volunteer at the museum, said, "I remember going to Shell Island as a child. About five years old, I reckon. My aunt and my grandmother used to take me down there. We went to Lofton's Hotel. Victoria Lofton and her husband had a hotel down there. It was a big thing and had a porch all the way around and you could look at the water almost from any place. My mother used to go there to the dances. Boy, she and my Aunt Mary. They'd go down there and dance up a storm. My grandmother went, too, but the older people didn't do too much dancing. They'd just sit around and let the kids play."

After Shell Island burned, Katherine, like many local blacks, spent more time at Seabreeze, a black beach north of Snow's Cut. "Everybody down there knew everybody else. They had nice homes down there, restaurants. Margaret Green [Grover Freeman's longtime girlfriend], she was a large woman and she could handle a boat. She would ferry people from Seabreeze over to Bop City. When she would pull that boat up to the pier, folks would crowd in there. Everybody admired her skill because you just didn't see women doing that sort of thing."

Katherine Ennett was photographed in 2000 at Cape Fear Museum. (Suesan Sullivan.)

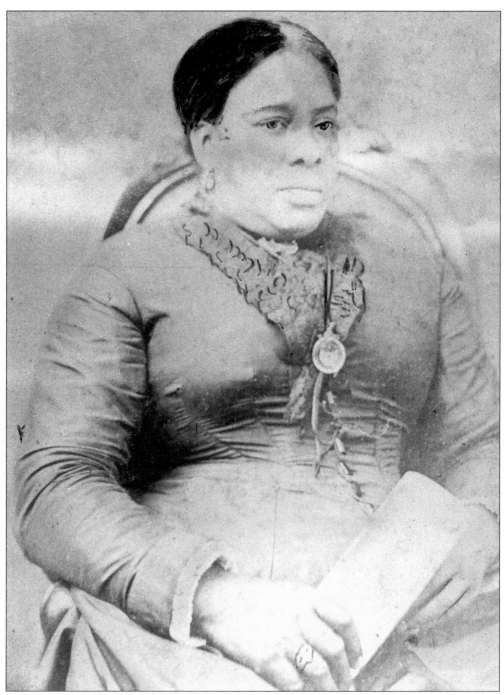

Victoria Lofton (1883–1949) built hotels at Shell Island and at Seabreeze. The one at Seabreeze, constructed in 1924, comprised 25 rooms and a dance hall where Roaring Twenties music reigned. Lofton was also founder of the Independent Order of Tents, the local chapter of a national organization dedicated to charitable deeds. In 1917, the Tents constructed a three-story building at 901 Castle Street, later named Victoria Temple in Ms. Lofton's honor. (New Hanover County Public Library.)

Beachgoers, possibly members of the Freeman family, line up for the camera, about 1903. Robert Bruce Freeman, born a free black in 1830, was of African-American and Native American descent. Through inheritance and acquisition, he and his two sons owned almost 5,000 acres of land in the Snow's Cut area. (IA3082.)

It was a quiet day in the diner at Seabreeze when these rare photos were taken, about 1920, but things were usually busier. At one time, Seabreeze consisted of three hotels, a boat pier, restaurants, a small amusement park, and a bingo parlor. (IA3080.)

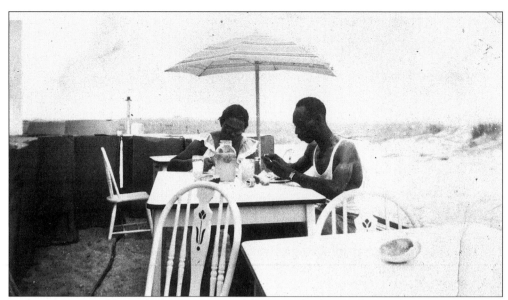

Seabreeze, pictured here about 1920, was a different sight during the Civil War when Robert Bruce Freeman allowed thousands of Confederate troops to camp there (Fort Jackson) and to pass through on their way to Fort Fisher. Freeman also granted Captain John Harper an easement for the Carolina Beach train route. (IA3085.)

Members of the Hill and Freeman families enjoy Freeman beach, or Bop City, about 1920. Blacks came to Seabreeze from all over North Carolina and several neighboring states during segregation. (IA3088.)

102

Five

THE NEIGHBORS

Someone has said that islands like Wrightsville Beach are merely necklaces of sand strung along the ocean. If so, there's a jewelry collection within the scope of southeastern North Carolina. Water sparkles all around us and waves break much the same way on all our beaches.

The proximity of waterfront land lying within the scope of Cape Fear Museum links places and stories. The Pearsall family once floated their Carolina Beach cottage to Wrightsville and put it on a new foundation, on Airlie Road. Bruce B. Cameron's dog disappeared one evening from Figure Eight Island and popped up later that night at Wrightsville, soaking wet from his joy swim across Mason's Inlet. Environmentally, our coast is chain-linked: man-made alterations on one beach are likely to affect neighboring ones.

The watery intersection of Boardwalk and Georgia Avenue offered nothing but potential, about 1898. Wearing two vocational hats, surveyor Eric Norden captured this image. (1980.36.154.)

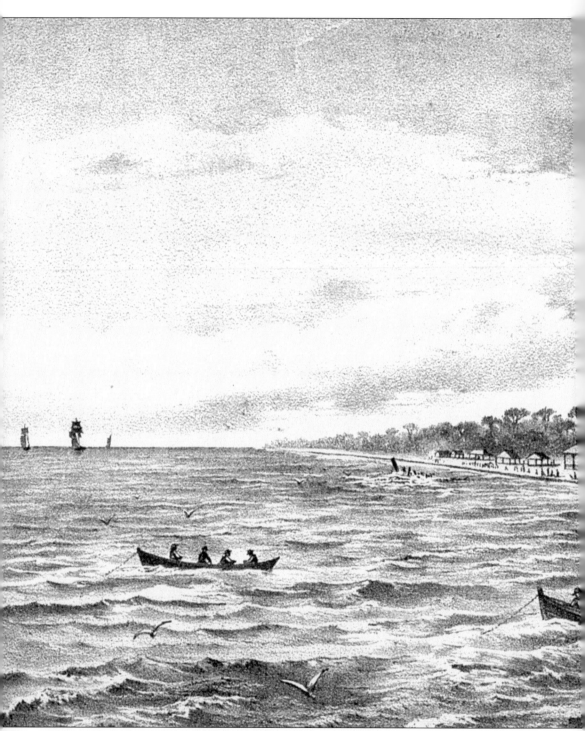

From 1888 until 1890, Captain John W. Harper ran passengers from Wilmington to Carolina Beach on his steamer *Sylvan Grove*, an 1858 vessel used originally to taxi commuters from New York to Harlem. Tourists could stay at Bryan's Oceanic Hotel (pictured on the right) or sail back out to the blockade runner ruins (left foreground) and fish for a few hours.

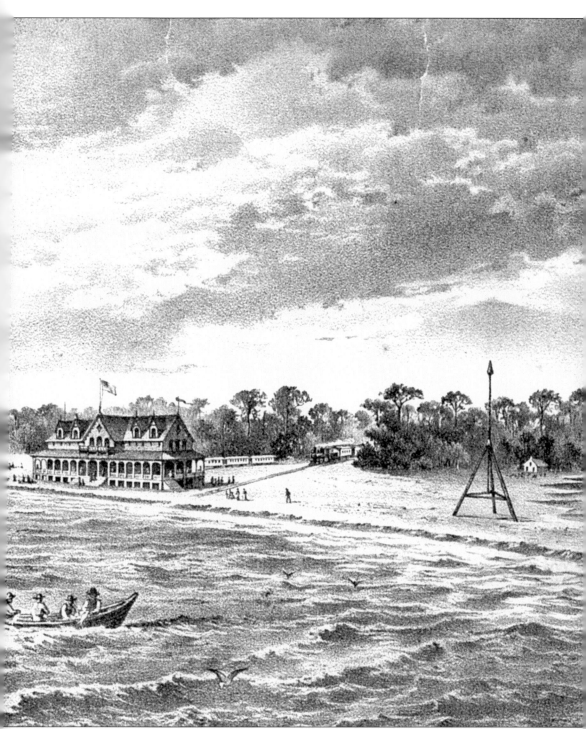

Major Charles Pattison Bolles, who created the artistic marketing, is known better as the civil engineer who oversaw construction of the Fort Fisher Civil War batteries. In 1890, the *Sylvan Grove* burned and Captain Harper replaced it with the steamer *Wilmington*. (1981.1.62)

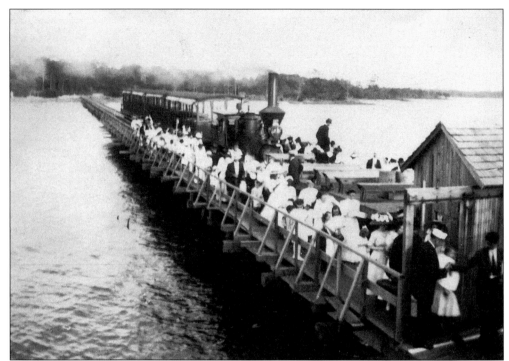

In August 1909, this spiffy group rode from the steamer wharf to Carolina Beach on Captain John Harper's train, the *Shoo Fly*. "It was Captain Harper and his little train and steamboats that turned a seacoast wilderness into a beautiful summer resort," wrote author Lewis Philip Hall. (1991.64.1.)

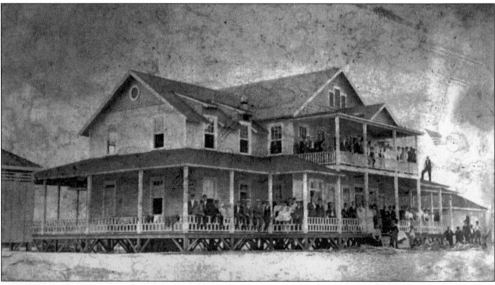

The first clubhouse of the Hanover Seaside Club, designed by Henry Bonitz, was built at Carolina Beach in 1898. By 1906, members, most of German descent, had a second clubhouse at Wrightsville Beach. The Carolina Beach building was damaged by the 1899 hurricane and was less accessible. Eventually, the northern facility won out. (Hanover Seaside Club Archives.)

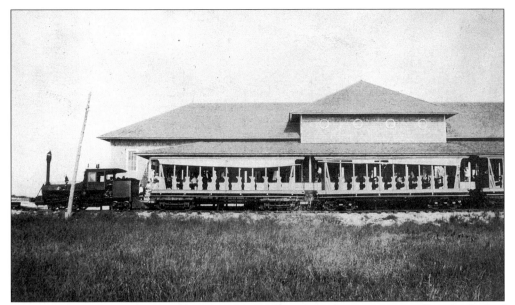

Captain John Harper engineered his plans for the *Shoo Fly* to drop passengers off on the deck of the 1910 Carolina Beach pavilion. The 13,000-square-foot pavilion, also designed by Henry Bonitz, housed a dance hall, a bowling alley, and an eatery. (1987.23.10.)

About 1928, Will Harllee Bordeaux rode around Carolina Beach in style. The G.C. Bordeaux residence (pictured on the right), like many other early dwellings at Carolina Beach, resembled a townhouse more than a beachhouse. (1982.82.2.)

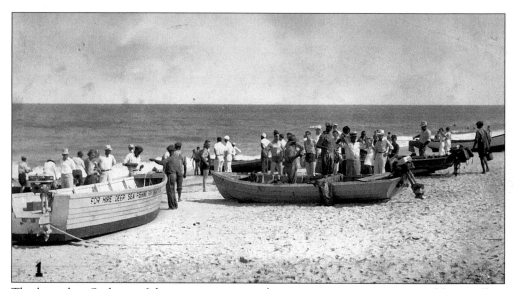

The legendary Seabreeze fishermen went out early every morning, one motorized boat pulling the others. They sailed back in the early afternoon and beached their boats, with a little help from the seafood customers. The boy seated on the right is Freddie Block, about 1938. (New Hanover County Library.)

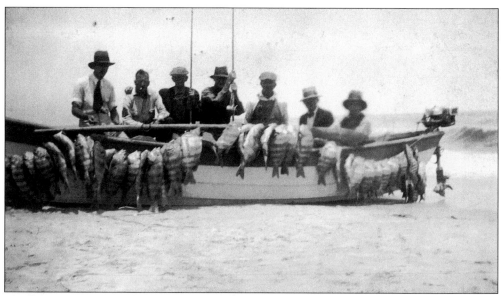

The fish were tied together with sea oats; each bunch, anywhere from two to four fish, cost only a quarter, including cleaning. Though flounder were their hottest-selling fish, sheepshead like these were the most photogenic. (1990.55.7.)

Here, two members of the Freeman fishing crew display their harvest, about 1928. Before rod and reel fishing, area fishermen used hand-lines, each equipped with a sinker and one or two large hooks. The line was swung around the head until proper momentum was reached and then let go. They reeled the line in by wrapping it around their arm, from elbow to hand. (1990.55.3.)

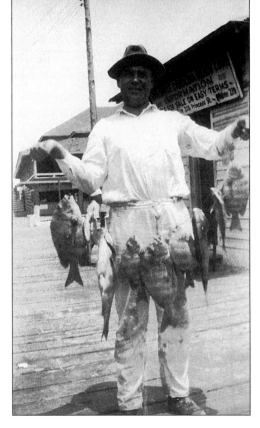

The Freeman fishing fleet caught most of their fish in a spot honored as "theirs," near Fort Fisher. At night, many of the hardworking fishermen moonlighted in the clubs and inns at Seabreeze. (1990.55.2.)

This was a street scene in Carolina Beach about 1920. Most residents, still hoping for their own beach cars, were disappointed when a fine road, Federal Point Highway, was built, linking Carolina Beach to Wilmington. (1990.55.14.)

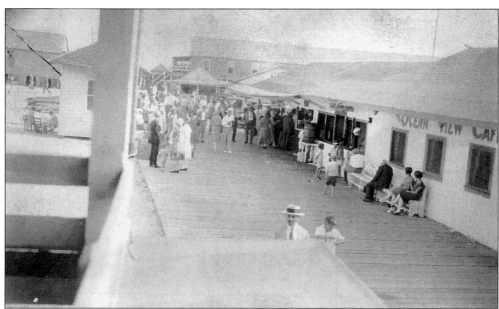

"From all sections of the state," read the 1920s publicity notice, "friends meet friends on the boardwalk at Carolina Beach." The Ocean View Hotel and Cafe were managed by G.L. Edwards and B.D. Bunn. (1990.55.12.)

In the late 1920s, a number of things were sure to draw spectators: a shark fin, a daring rescue, or (since they weren't lined back then) wet bathing suits on pretty girls. (1990.55.5.)

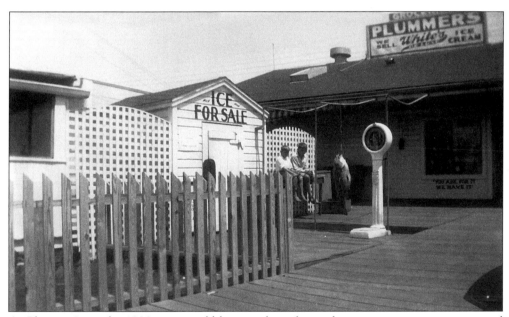

At Plummer's, in the 1930s, you could buy anything from a hammer to an ice cream created locally by White's. They didn't need to stock produce, though. Peddlers came door to door each day heralded by the chant, "I got 'em." (1990.55.6.)

First cousins Franklin Block, Felice Guld, and David Block were all summer residents of Carolina Beach in the 1930s. (IA5199.)

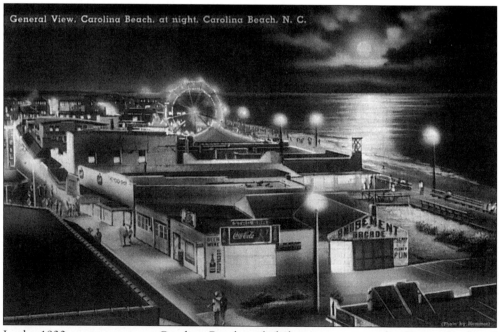

In the 1930s, amusements at Carolina Beach included a merry-go-round, a Ferris wheel, and two large outdoor bowling alleys. There were also three gambling spots where even children were welcome: Penny Pitch, Bingo, and Hearts. (1981.1.80.)

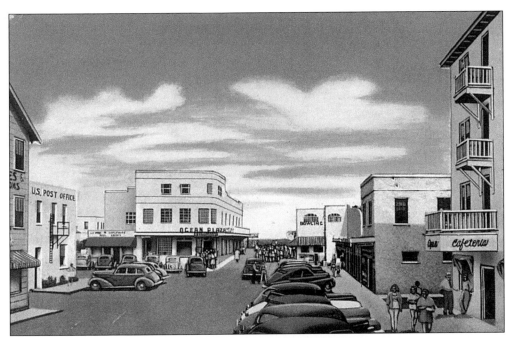

Carolina Beach looked pristine in this 1930s postcard, but just a mile away, the first oceanside house on Wilmington Beach was an ancient log cabin. (2000.10.23.)

John Van B. Metts, Mary Tom Walbach, and Kader Brown enjoy themselves at Carolina Beach, about 1938. Most weekends, though, Johnny Metts was at Wrightsville, dancing at Lumina. (Brown-King.)

During World War II, Hannah Block trained lifesavers at Carolina Beach. Standing in front of A.L. Mansfield's Amusement Park, about 1943, this group includes Billy MacDonald (center, top row), David Sparks (right, top row), the head lifeguard's son, Franklin Block, and Nancy Liner (girl on right). (1991.50.5.)

Eighty-year-old Alex McEachern refused to leave his Carolina Beach cottage during Hurricane Hazel. To escape rising waters, McEachern and his dog climbed on top of a freezer in his pantry to ride out the storm. Even though the rest of the house was torn apart, the pantry was left standing. When the waters subsided, man and dog climbed down and made their way into town. McEachern is pictured here with Leon Futrelle (left) and Jack LeGwin (right), in 1931, 23 years before Hazel. (Claud Efird.)

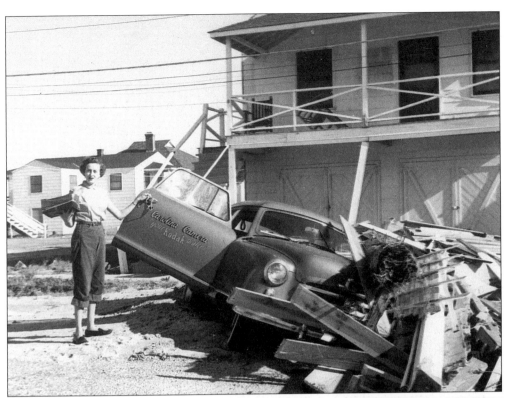

It wasn't an ideal Kodak moment. At Carolina Beach, a woman stands next to a bashed car that reads, "Carolina Camera, your Kodak dealer," following Hurricane Hazel, in 1954. (1980.42.58.)

Robert Edward Harrell, photographed here at the dedication of the Fort Fisher Visitors' Center in 1965, was better known as the Fort Fisher Hermit. From 1955 to his death in 1972, he was a "recluse," but also a tourist attraction. One year 17,000 visitors signed his guest book. Harry Warren, assistant director of Cape Fear Museum, lectures frequently on Mr. Harrell. (Fort Fisher State Historic Site.)

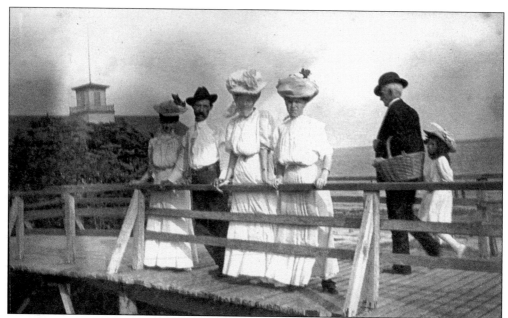

Maggie and Eugene Philyaw (far left) enjoyed a day at Fort Fisher, about 1887. The Federal Point lighthouse, on the left, is barely visible for all the vegetation. However, all that changed when the beach began to erode rapidly in the 1920s. In 1931, 44 years after this photo was taken, Mrs. Philyaw worked to secure federal funds to preserve Fort Fisher. (1997.113.14.)

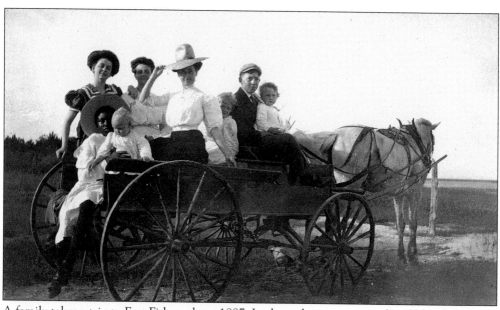

A family takes a trip to Fort Fisher, about 1887. In those days, getting to the old battlefield was half the battle. (1997.113.4.)

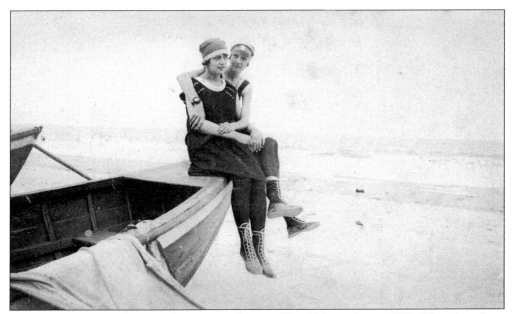

Two women in matching outfits sit on a boat at Fort Fisher, about 1888. After describing modest outfits similar to these, a visitor to the area wrote, in 1888, "But I saw no man or woman who seemed to care about the scarcity of apparel. It was sufficient to be decent and that is all that is necessary." (1997.113.6.)

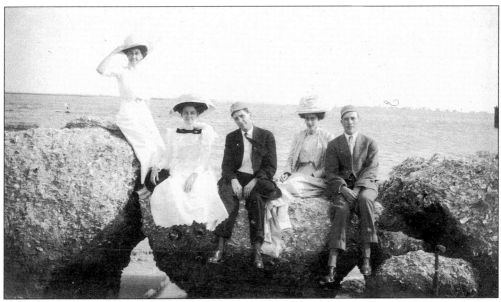

Maggie Philyaw and friends sit on the "Rocks" at Fort Fisher, about 1888. Though granite was the chief ingredient, these hunks of coquina were also used during the construction of New Inlet. The project, designed by civil engineer Henry Bacon, deepened the channel and drew lots of local attention. (1997.113.5.)

Photographer Bayard Wootten (1875–1959) eventually made a name for herself, not only for trailblazing as a female photographer, but also for capturing images of the poor, both black and white. Here, she steps into her own camera's eye and stands next to two 12-inch mortars at Fort Caswell, in 1910. (1981.10.143.)

This is "The Midway" at Fort Caswell, photographed by Bayard Wootten in 1910. She would have preferred the simple art of photography, but personal economics forced her to capitalize, developing her photos as postcards. She sold six cards of a single pose for 50¢ and group shots for a nickel apiece. (1981.10.144.)

Claude Howell photographed Margaret Groover, Ed Weaver, and Mary Weaver leaving Southport for Bald Head Island, in 1947. Once known as Smith Island, Bald Head has its own history of shipwrecks, war stories, salty tales, and pirate lore: Buccaneer Stede Bonnet was captured in 1718 within sight of the island. (1997.55.477.)

Katherine Meier enjoys Bald Head Island, in 1937. Lush vegetation still covers much of the island, creating a haven for birds and other creatures. In 1925, the U.S. National Museum reported that Bald Head was "a zone of integration for a number of species." (1998.128.7.)

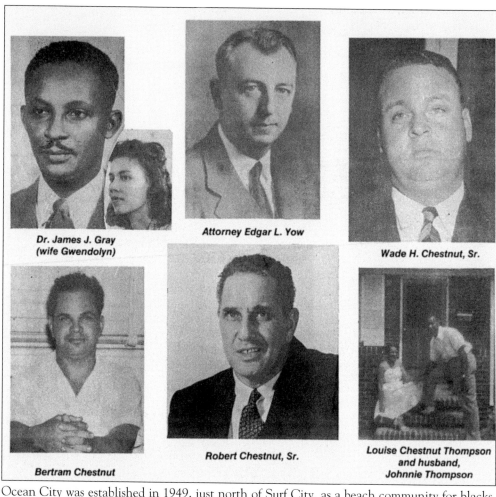

Dr. James J. Gray
(wife Gwendolyn)

Attorney Edgar L. Yow

Wade H. Chestnut, Sr.

Bertram Chestnut

Robert Chestnut, Sr.

Louise Chestnut Thompson
and husband,
Johnnie Thompson

Ocean City was established in 1949, just north of Surf City, as a beach community for blacks. Edgar Yow gets credit for the idea, but Dr. James Gray convinced the Chestnut family of Wilmington to develop Ocean City into a large waterfront community. The Chestnut brothers, Wade, Bert, and Robert, had already achieved success with their own automotive repair business, when Wade launched out on his own to create a black oceanfront resort. "Wade H. Chestnut, Jr. was the moving spirit behind the development of Ocean City," according to T.C. Jervay, publisher of the *Wilmington Journal.*

In 1949, Wade Chestnut Jr. took a group of people to Ocean City to share his dream. Mr. Jervay, a member of this group, said, "There was a floating narrow bridge which connected the beach with the mainland. We only saw sand, sky, and water [but] he painted such a picture. Wade told us he was going to build a city. He said he meant to give our people a beach of which they would be proud and an outlet for their social activities together with the health benefits that would be derived from such a place."

By the mid-1970s, Ocean City was the summer home to hundreds of North Carolinians and boasted its own fishing pier. Today, development continues under the management of Wade Chestnut III, who has recently refurbished the Wade H. Chestnut Memorial Chapel. Appointments include a baptismal font made of a giant killer clam shell, a cross sculpted by Al Frega, and a lectern made from plates of an old printing press. (Caronell Spaulding Chestnut.)

John Kelly took this photograph on Topsail Beach, shortly after Hurricane Hazel. It was no cookie-cutter house. Topsail has always had a sprinkling of zany architecture. (1984.75.16.)

NORTH TOPSAIL ISLAND

In the late 1970s, North Topsail Beach was still a wilderness. Wildlife, including some enormous snakes, lived under an umbrella of gnarled oaks and there was not a single house on the northernmost mile of the island. A jog down the beach was usually a solitary experience. But all that changed about 1980. (Tom and Jerry Cards.)

According to Nola Nadeau, author of *An Island Called Figure Eight*, the stretch of land shaped somewhat like the digit was owned by the Moore, Foy, and Hutaff families, from 1762 until the 1950s. For centuries it was home only to wild ponies and an occasional squatter. During Prohibition, whiskey stills dotted the island, and in the midst of World War II, the Army Air Corps used the desolate spot for target practice. This photo by Freda Wilkins was taken about 1982.

In the mid-1950s, businessmen Bruce and Dan Cameron, Richard Wetherill, and Raeford Trask purchased Figure Eight. The Cameron brothers spearheaded the development and made the island their summer home. Dan Cameron, who started an annual Fourth of July parade at Wrightsville Beach, moved it to Figure Eight Island in the 1960s. He is pictured here, about 1971, leading the way, in red, white, and blue.

Man-made canals like the one seen here make for convenient docks, but only two were cut before environmental restrictions took effect. Here, two young Wilmingtonians catch the breeze at Figure Eight Island, in April 1990.

The Fleet House on Beach Road South won architectural awards for innovative design. This photo was taken by Freda Wilkins, about 1985.

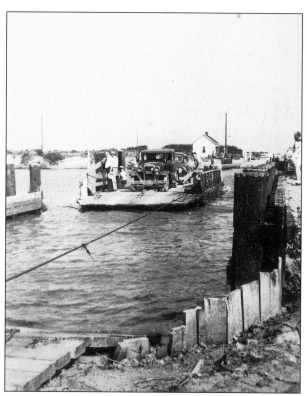

Snead's Ferry, so named because of Robert W. Snead's ferry about 1760, still had one about 1930, when this photo was taken. Snead's Ferry fishermen were famous for supplying area beach restaurants with tubs of tasty oysters and clams. (1997.105.10.)

Alex McEachern (on left), owner of Echo Farms Dairy, was an avid fisherman. Local pioneer aviator Warren Pennington used to fly McEachern to various desolate beaches where he would land in hard-packed sand. Pennington would return to carry him home late in the afternoon. One day when he realized Mr. McEachern had forgotten his lunch, the playful pilot flew low and dropped a picnic basket right at his feet. This photo was taken at a local beach, probably Figure Eight or Topsail Island, about 1925. (Claud Efird.)

SELECT BIBLIOGRAPHY

Barnes, Jay. *North Carolina's Hurricane History*. Chapel Hill and London, 1995.

Benson, Rupert and Helen. *Historical Narrative of Wrightsville Beach, 1841–1972*. Wilmington, 1972.

Block, Susan Taylor. *The Wrights of Wilmington*. Wilmington, 1992.

Campbell, Walter E. *Across Fortune's Tracks: A Biography of William Rand Kenan, Jr.* Chapel Hill, 1996.

Carnell, David W. and Barbara L. Rowe. *The Simmons Sea-Skiff: A Boat for All Seasons*. Wilmington, 1995.

Cashman, Diane. *Cape Fear Adventure*. Woodland Hills, 1982.

Cotten, Jerry W. *Light and Air: The Photography of Bayard Wootten*. Chapel Hill, 1998.

Duke University. Special Collections, Perkins Library.

Franks, Georgie Hurst. *A Brief History of the Wrightsville Sound Community*.

Gruber, Leslie. "Back Then," *Wilmington Star News* column.

Hall, Lewis Philip. *Land of the Golden River, Vol. 1*. Wilmington, 1975.

Hutteman, Ann Hewlett. *One Hundred Golden Summers: A History of the Hanover Seaside Club, 1898–1998*. Wilmington, 1998.

Island Quarterly, published by Bryant Real Estate, articles by Jay Johnson.

Johnston, William R. *William and Henry Walters, The Reticent Collectors*. Baltimore, 1999.

Lower Cape Fear Historical Society Archives.

Reaves, William M. Family files. New Hanover County Public Library.

Reaves, William M. *Strength through Struggle*. Wilmington, 1998.

Russell, Anne. *Carolina Yacht Club Chronicles*. Wilmington, 1993.

Russell, Anne. *Wilmington: A Pictorial History*. Norfolk, 1981.

Sprunt, James. *Chronicles of the Lower Cape Fear, 1660–1916*. Wilmington, 1916.

Stick, David. *Bald Head*. Wendell, 1985.

Watkins, Greg. *Wrightsville Beach: A Pictorial History*. Wrightsville Beach, 1997.

Wilmington Star News, archived at New Hanover County Public Library.

Wrenn, Tony P. *Wilmington, North Carolina: An Architectural and Historical Portrait*. Charlottesville, 1984.

Documented oral histories:

Interviewed by Susan Block: Annie Bryant Peterson, Eva S. Cross, Katherine M. Cameron, Naomi Yopp, Silvey and Cecil Robinson, Luther T. Rogers, Cecil Hunt, Hannah Nixon, George Evans, Mary Fields, James L. Sprunt Jr., and Kenneth Sprunt;

Interviewed by W. Andrew Boney: Lillian B. Boney;

Interviewed by Linda P. Nance: John Hall;

Interviewed by Beverly Smalls: Frank Hill.

PHOTOGRAPH DONORS

Lower Cape Fear Historical Society, New Hanover County Library, *Wilmington Star News*, Elizabeth Brown King, Silvey and Cecil Robinson, Bill Creasy, Suzanne Joyce, Barbara Marcroft, Robert M. Fales, Frank Hill, Catherine Solomon, Eva Cross, Hugh Morton, Margaret Banck, Fannie Northrop Kletzien, Lynda B. Bohbot, James L. Sprunt Jr., Earl A. Jackson, Nell Barnhill, Dan Cameron, Tabitha H. McEachern, Robert S. Bridgers, Ellen Anderson, Catherine Solomon, William Baggett, Wrightsville Beach Museum of History, Hanover Seaside Club, Fort Fisher State Historic Site, George T. Clark, Barbara Bear Jamison, Mary Robinson Haneman, Catherine M. Cameron, George Nevens, Henry B. McKoy, Everett Huggins, Henry Jay MacMillan, Jane MacMillan Rhett, Betty Foy Taylor, Lillian Sebrell Paso, Robert A. Little Jr., Anne Russell, Sadie Block, Robert Cantwell, Jocelyn Strange, Larry B. Lee, James R. Lee, Grace Slocum, Claude Howell, Hannah Block, James E.L. Wade, Billy Mason, Suzanne N. Ruffin, Edith M. Friedberg, Bill Chambers, Susan W. Gustafson, Laura Schorr, Julia Humphrey, Bill Reaves, Anna Pennington, Elizabeth Day, C. Monroe Shigley, Jessie Moseley, Claud Efird, Roi Penton, Janice Kingoff, and Reid Nathan.

INDEX

Airlie, 21, 75, 91–94
Appleberry family, 64
Bald Head Island, 119
Banck, Margaret G., 45
Barroll family, 60
Bear family, 11, 57, 62
Bellamy family, 34, 60, 68
Block family, 69, 108, 112, 114
Blockade Runner Hotel, 78
Bolles, Charles Pattison, 104, 105
Boney family, 34
Bonitz, Henry, 38, 106
Bop City, 96, 98, 99
Bordeaux family, 107
Bridgers family, 9, 37
Brinkley, David, 26
Brown family, 46, 70–72, 76, 78, 113
Burns, James Moss Jr., 84
Burruss, Evoline, 9
Calder, Robert, 37
Cameron family, 57, 103, 122
Cantwell family, 34
Carolina Beach, 103–115

Carolina Yacht Club, 15, 22, 52, 56
Chase, H.M., 19
Chestnut family, 120
Clarendon Yacht Club, 15
Clark, George T., 87
Corbett family, 46, 70
Creasy family, 44, 84
Cross family, 73, 74, 80
Ennett, Katherine, 99
Evans family, 91–94
Everett family, 72
Feast of the Pirates, 48, 49
Fields, Mary Hargrove, 96
Figure Eight Island, 85, 103, 122–124
Fort Caswell, 118
Fort Fisher, 116, 117
Franks, Georgie Hurst, 94, 95
Freeman family, 54, 97, 98, 101, 102, 108, 109
Frownfelter, Peggy, 65
Gouverneur, M.F.H., 19
Green, Margaret, 96, 98, 99
Grimes, 73
Hall, Benjamin Franklin, 14, 31, 32

Haneman family, 79, 82, 83
Hanover Seaside Club, 45, 76, 106
Harper, Captain John, 104, 105–107
Hartsfield, W.R., 52
Herbst family, 53, 54, 55
Howell, Claude, 56, 79, 88, 89
Hunt, Cecil, 40, 41
Hunt, Governor James B., 83
Hurst family, 94, 95
Hurricane Hazel, 76–78, 114, 115, 121
Hutaff family, 85
Hutteman, Ann Hewlett, 76
Jackson, Earl A., 75
Jones, Clarence, 97
Jones, Pembroke, 21–23, 91
Kenan family, 78, 84, 93
King, Katherine, 65
Kingoff family, 96
Lacewell, Juanita, 72
Latimer, William, 12, 13
Lee, Lawrence, 39
Lewis, Lawrence Jr., 78
Little Chapel on the Boardwalk, 17
Lofton, Victoria, 99, 100
Lumina, 24–27, 30, 46, 48, 49, 64, 69, 83, 89
MacMillan family, 18, 19, 61, 90
MacRae, Hugh, 16, 29,
Marcroft, Barbara, 68
McEachern family, 85, 114, 124
Meier family, 53, 58, 59, 65, 69, 119
Metts family, 14, 22, 23, 35, 70, 113
Morgan, Marshall, 85
Moore, Louis T., 47
Morton, Hugh, 69, 78
Mount Lebanon Chapel, 20
Nathan family, 11, 81
Nevens, George, 52–55
Newells, 72
Nixon, Hannah, 98
Norden family, 38, 90, 103
Northrop family, 14, 31, 32
Ocean City Beach, 120
Ocean Terrace Hotel, 78
Ocean View Railroad, 12
Oceanic Hotel, 16, 17, 42, 43, 49, 62, 95
Pearsall family, 103
Pembroke Park, 75, 91
Penton family, 95
Peterson, Annie Bryant, 58, 80
Philyaw family, 120, 121
Pomander Walk, 25, 64
Presson family, 42

Riesz, Charles W. Jr., 25
Robert's Market, 73, 80
Robinson family, 42, 43
Rogers, Luther T. family, 40, 41, 58, 62
Ruark, Robert, 60
Ruffin family, 35, 67
Schloss, Marx, 10
Seabreeze, 96–102
Seashore Hotel, 17, 22, 30, 31, 95
Shell Island, 19, 40, 41, 91, 94, 96, 98–100
Sidbury, Dr. James Buren, 86
Simmons family, 55, 86
Snead's Ferry, 124
Solomon family, 27, 28
Sparks, Boyden, 45
Sprunt family, 33, 36, 37, 66, 86
Sternberger family, 62, 63
Stovall, Nancy, 57
Strange, Allan, 57
Stevenson, Reston, 36
Tarrymoore Hotel, 16
Toomer family, 7
Topsail Beach, 121, 124
Trouble the Whale, 58
Wilmington Seacoast Railroad, 12
Walker family, 67
Wallace family, 39
Walters family, 22, 91–94
Watkins, Greg, 84
Werkhauser, Bud, 56, 57, 72
Williams family, 16, 18, 21, 61, 90
Wit's End, 79
Wootten, Bayard, 118
Wright family, 17, 20, 34, 35, 40, 69
Wrightsville Beach Museum of History, 84
Wrightsville Marina, 87
Yopp, Naomi, 80

This man had his hands full. William A. Williams photographed the Wrightsville Beach scene in 1916. (1980.45.39.)